out of
beirut

MODERN ART OXFORD

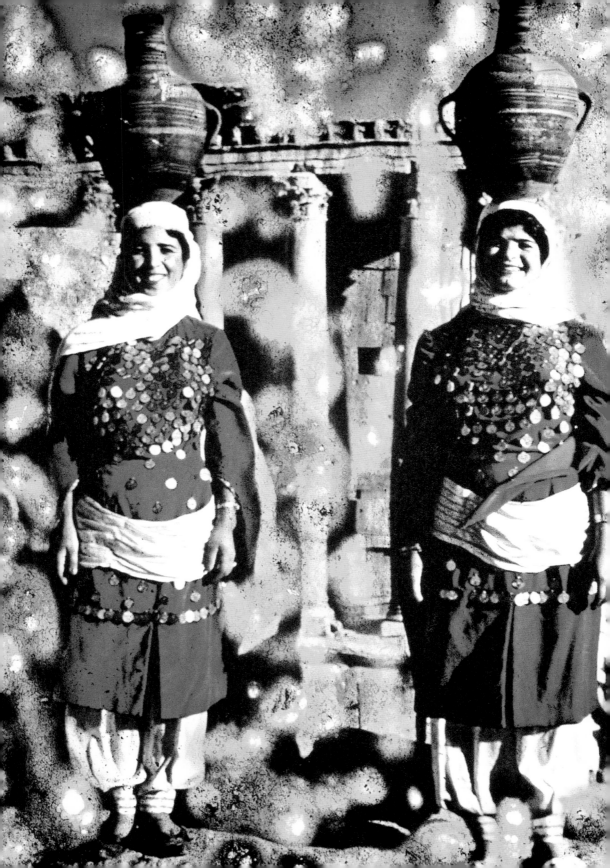

Joana Hadjithomas and Khalil Joreige, *Wonder Beirut:*
The Story of a Pyromaniac Photographer, 1999–2006.
Postcard.

Foreword
Andrew Nairne

The names of certain cities resonate around the world. Beirut is one of those cities. A famous resort, a place of culture and style became the site of terrible violence and trauma. Fifteen years on from the official end of the civil war political instability, bombs and assassinations still dominate the international headlines. Yet Beirut is changing and so are perceptions. The travel and feature writers are back. For all the remaining bullet holes, the sky is still blue for nine months of the year and the sea a sparkling azure. There are exotic yachts in the harbour and the night clubs and bars on Monnot Street are effervescent. The prices in the rebuilt parts of the centre, near Martyrs' Square, reflect the return of tourists and economic investment. Once again artists, fashion designers, architects, writers and musicians are attracting notice beyond Lebanon's borders.

Out of Beirut, organised by Modern Art Oxford, is a major exhibition, a symposium and a book. For a generation of Lebanese artists coming of age during the civil war and in the subsequent years, Beirut is above all their city, to be engaged with and reclaimed. Our aim has been to give a new audience the opportunity to experience their remarkable work. As well as giving us an infinitely more complex picture of Beirut and Lebanon the artists in *Out of Beirut* offer startling and subtle insights; questioning the purpose and power of art at a time of global anxiety.

We are, first and foremost, grateful to the artists who so willingly engaged with this project. Many are presenting their work in the UK for the first time. Their dialogue and collaboration have been essential to the development of the exhibition, the symposium and this publication. We cannot thank them enough.

Our initial research for *Out of Beirut*, the exhibition, would not have been possible without the advice and assistance of Christine Tohme. As Director of Ashkal Alwan Association for Plastic Arts in Beirut, Christine has been one of the prime movers of the Lebanese contemporary art scene. Her series of *Homeworks* forums, a biennial platform for art, discussions, lectures, film screenings and performances highlighting cultural practice in the Middle East, inaugurated in 2001, has become one of the most innovative cultural events to be produced in the region and internationally. As well as offering a sounding board for the project in Oxford, Christine and her colleagues Masha Refka and Nidal Abu Mrad at Ashkal Alwan have been invaluable liaisons between ourselves and many of the artists whose work is presented in the exhibition and in this book. We are delighted to present a film programme curated by Christine, as part of the *Out of Beirut* exhibition, which includes films by artists from Lebanon, Turkey and the Middle East not previously seen in this country.

A project such as this relies on the skills, expertise and collaboration of many. We are especially grateful to Simon Harvey, Kaelen Wilson-Goldie and Stephen Wright for their contributions to this book, which individually and collectively, offer an expanded context in which to reflect on art from Beirut. Our thanks and appreciation also go to Stuart Smith and Victoria Forrest at SMITH for their intelligent design of this book and its sister publication featuring the symposium papers.

Out of Beirut stems from a research trip to Beirut and Cairo in April 2005, initiated and organised for a group of UK curators and gallery directors by Arts Council England and Visiting Arts. The chance to travel, to mix with others working in similar fields and to experience different contexts in which art is produced is as important for curators as it is for artists. This opportunity has been nurtured into what we

believe to be a significant and multilayered project and has resulted in
an entirely new network of connections with artists, writers, curators
and thinkers in Beirut and internationally.

We are tremendously grateful to Arts Council England South East,
in particular Phil Smith who championed our involvement and our
application for a "Grants for the Arts" award to help make our vision
for the project a reality. Additional funding for research was provided
by the Roberto Cimetta Fund in Paris, who supported one of the trips
to Beirut at a particularly crucial time in the project's development.
We are grateful to Visiting Arts for their financial support and their
advice. We would particularly like to thank Jon Fawcett and Ann Jones,
respectively the Head and former Head of Arts at Visiting Arts; Nansi
O'Connor, Samar Martha and Camilla Canellas, former Head of Visual,
Media and Applied Arts, Visiting Arts. Camilla and Samar, who organised
the original research trip and provided invaluable information on artists
and cultural spaces in Beirut, have been unflagging supporters of this
project through their advice and specialist knowledge of the region and
of the main cultural players within it. Conrad Bodman, Senior Visual
Arts Officer, Arts Council England, London has also been a tireless
champion for the project as has Andrea Rose, Director, Visual Arts
at the British Council London, for which we cannot thank them enough.

We are also indebted to Lyne Sneige, Projects and Promotion Manager
at the British Council in Beirut, who has been an invaluable colleague.
We have benefited greatly from her encouragement and assistance in
bringing so many artists from Beirut to Oxford for the exhibition and
for the symposium with the support of Middle East Airlines.

In Oxford, our thanks are numerous. We would especially like
to thank Eugene L. Rogan, Professor at St. Antony's College, Alexis
Tadié, Director of the Maison Française, and Dr Michael Burdon, Dean
of New College, Oxford, for their collaboration on the symposium and
performance events forming part of *Out of Beirut*.

The dedicated team at Modern Art Oxford has been vital to every
aspect of the project, in particular, Assistant Curator Johanna Empson,
Programme Administrator Erica Burton and Gallery Manager Tom Legg.
Community and Education Manager Sarah Mossop and her Co-ordinator
Fiona Heathcote have created an innovative programme of workshops for
young people. The press and marketing has been skilfully undertaken by
Kirsty Kelso, Head of Marketing and Development and Press Officer
Meera Hindocha with the support of Communications Administrator
Katherine Hart, who has assisted with the organisation of the symposium,
film screenings and performances in different venues in Oxford. Together
with Head of Finance, Caroline Winnicott, the finance and administrative
team of Barbara Naylor, Lucy Tams and Luisa Summers, and our Operations
Manager's Natasha Denness and Donna Waterer, they have worked
tirelessly to make this project possible.

Finally, *Out of Beirut* in all its manifestations would not be happening
but for the vision of Modern Art Oxford Senior Curator, Suzanne Cotter.
She has not only initiated and curated a singularly striking exhibition
with both acuity and determination but also devised the international
symposium and this substantial accompanying book. With her team she
has led the realisation of a project which will be remembered as among
the most ambitious and important in our organisation's forty year history.

PAOLA YACOUB
MICHEL LASSERRE
A BRIEF JOURNEY TOWARDS SCEPTICISM

We first met in 1996.

Up until then, Lebanon was, first and foremost, an experience of war which I had lived through during my childhood, and experienced even more vividly during my teenage years as an assistant to a war reporter from the Gamma Agency from 1987 to 1991.

This is where these first snapshots come from: photographs without any particular aim made during surveillance operations and fighting. It was a digression through images; an implicit deviation from the practice of documentary photography.[1] There is a certain aimlessness, but the shot was always taken in circumstances over which we never had any control.[2]

In fact, these shots are the consequences of fear, and of the way in which fear clung to those places. Everybody who came through Beirut knew what it was to be suddenly frightened in the middle of a street, sometimes without really knowing why, even when they had been along it many times before. They did not see it in the same way any longer. From then on we started to explore the way in which emotions such as fear or joy inscribed themselves on places, often without our being aware of it.

Within the changing aspects of those places and based on the idea that "I do not see this street where I am frightened in the same way", we looked to ac knowledge their changing aspects as they affected different areas. We decided to apply a form of *Gestalt* theory, based on Wittgenstein's theories on the perception of aspects,[3] to the unstable historical situation of Southern Lebanon. It was not a question of showing the traces of change in these areas: the aspect of a place can change without any change to its physical form. It was an artistic practice born of emergency: we wanted to revive those situations, to take our knocks again.

In the exhibition *Aspects, Accents, Frontières* in Paris in 2002,[4] we presented three slide shows consisting of snapshots of places interleaved with texts about the places themselves. The perception of these pictures was dependent on the texts, but also on the associations with news coverage of those areas. We wanted to demonstrate this dependence. In order to do this, we had to assume an external position; de-dramatising the artistic presentation.

To go even further, we were dealing with an absorption of the news by places and images. It is this co-dependence that interests us: how the news, a purely industrial product, immediately exhausted in the present, is implicated in the "affects" of images and places.

Everyone remembers where they were on 11 of September 2001, the places where we caught the news, like we catch an illness. We were already familiar with this field of 'news'.[5] It brought us back to years of war, glued to the transistor, and also to the beginning of doubt, as, very quickly, we learnt to take the information supplied to us with a pinch of salt. The post-war period only reinforced this doubt when we finally met our former enemies. We then noticed that places and images had contracted

1 We identified this deviation through the curatorial work of Catherine David, with whom we collaborated in 2002. For an overview of current practices, see Jan Verwoert, "Research and Display: Of Transformation of Documentary Practice in Recent Art", in *Untitled (Experience of Place)*, Koenig Books, London, 2003.

2 It was not possible to apply a systematic approach in the way of, for example, Douglas Huebler in his *Duration Piece, number 5*, New York, April 1969.

3 The perception of aspects has been developed by Ludwig Wittgenstein, in his *Inner and Outer: Last Writings on the Philosophy of Psychology*, vol. 2, ed. and trans. G.E.M. Anscombe et al., Oxford, 1982, after the work of Dieter Köhler, taking up, among others, the figure of the duck-rabbit

introduced by Joseph Jastrow. It is also part of another tradition, that of the texts of Bataille, Foucault and the *nouveau roman* in France. See Hubert Damisch, "Du Mot à l'Aspect", in Georges Bataille, *Après Tout: Actes du Colloque*, Berlin, 1995; Michel Foucault, *Dits et Ecrits*, vol. 1, Gallimard, Paris, 1994, p. 282. Joseph Kosuth refers to the discrepancy of aspects, as a form of instruction. "[2] to shift voluntarily from one aspect of situation to another", *Seventh Investigation (Art as Idea as Idea) Proposition One*, 1970.

4 Paola Yacoub and Michel Lasserre, *Aspects/Accents/Frontières*, *Maquis*, 19 Sept.–24 Nov. 2002, Le Plateau, Paris 2002.

5 We benefited, at that time, from the experience of press reports, but also from strategic studies on information made in association with the war correspondent of *Le Monde* in Beirut, from 1991 to 1998.

Opposite and on following pages:
Paola Yacoub and Michel Lasserre, *Summer 88*, 2006.
"These snapshots of Beirut were taken in 1988 while
accompanying a photo-journalist from the Gamma Agency.
They were shot alongside the photographs taken for press
coverage of the war but without any particular aim."

all sorts of news events, even those events on which
we had no real opinion. It was decisive in defining
our position of scepticism which forms the basis of
our work.[6] How can we discount our acceptance of
news coverage so as to see its impact on places and
images? During the war, we got into the habit of
waiting for the impact of the news to tail off before
even trying to evaluate it. Thus we let the emotional
charge cool down. We are using images in the same
way; it is this quality that we find, after the fact as it
were and outside of all acceptance of what is called
"information", that interests us.

It is not our purpose to formulate yet another
form of media critique but rather to bring an
emotional dimension to our position of scepticism.
Scepticism consists of suspending our judgement.
Positions of scepticism are rare in painting. They
have nothing to do with the fictionalisation of the
real. One finds scepticism in the work of the
seventeenth-century painter Philippe de Champaigne
who was associated with Jansenism, a movement
that embodied scepticism. Scepticism is evident in
relation to reports of war in the drawings of Watteau.[7]
Gerhard Richter's War Cut[8] also assumes a position
of scepticism.

More recently, we have looked into the
geographical distribution of scepticism. It can be
found, for example, in the evolution of collective
spaces before the fall of the Berlin Wall. With our
project OV (2003–6), we showed photographs taken
in cities together with extracts from news reports.[9]
The dialogic play between the visible and the failures
of the image is reflected in the particular quality of
the image taken with portable telephones, or in the
hundreds of news reports relayed by a plasma screen

in a café. The snapshots from OV were reworked
with the techniques of medium format and manual
developing. These images become a form of pure
protest. Today, we are working on the singularities
of images from this position.[10]

Paola Yacoub, Berlin, 12 March 2006

6 For some years we have been witnessing a renewal of interest in
 scepticism. Stanley Cavell, *The Claim of Reason: Wittgenstein,
 Skepticism, Morality and Tragedy*, Clarendon Press, Oxford,
 1979, and of course, Ludwig Wittgenstein, *On Certainty*, ed.
 and trans. G.E.M. Anscombe et al., Blackwell, Oxford, 1969.
 See also "Le Retour des Sceptiques", *Magazine Littéraire*,
 no. 394, January 2001.

7 Arlette Farge, *Les Fatigues de la Guerre*, Gallimard, Paris, 1996.

8 Gerhard Richter, *War Cut*, Walther König, Cologne, 2003.

9 Paola Yacoub and Michel Lasserre, *O.V. Retrospective*, DAAD
 Gallery, Berlin, 2005.

10 Paola Yacoub and Michel Lasserre, *Newsletter*, in progress,
 Berlin, 2006.

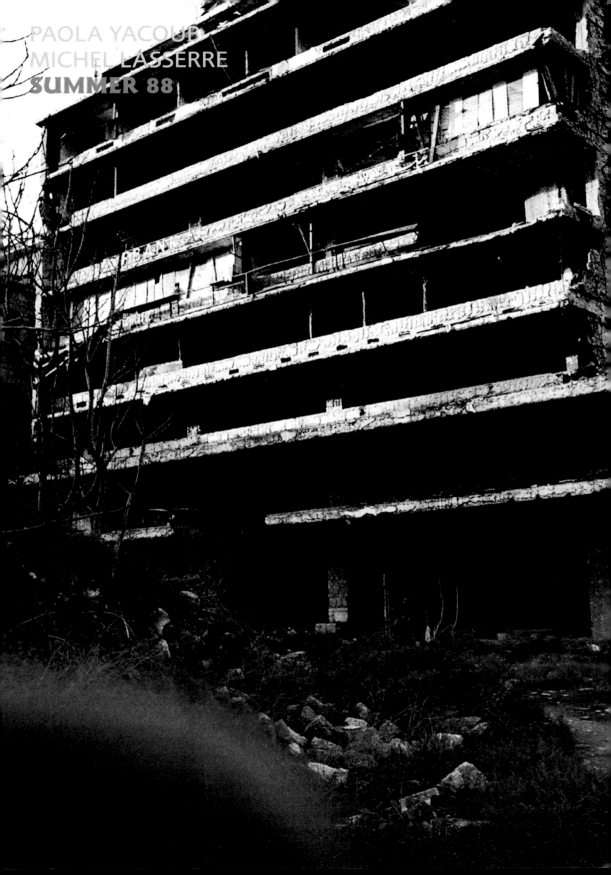

PAOLA YACOUB
MICHEL LASSERRE
SUMMER 88

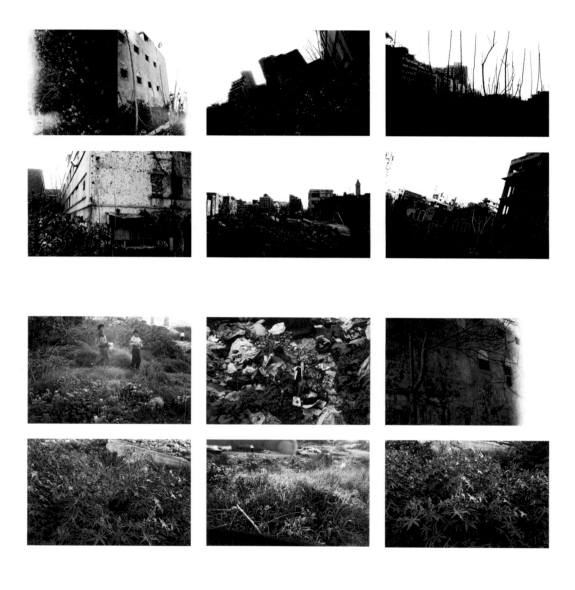

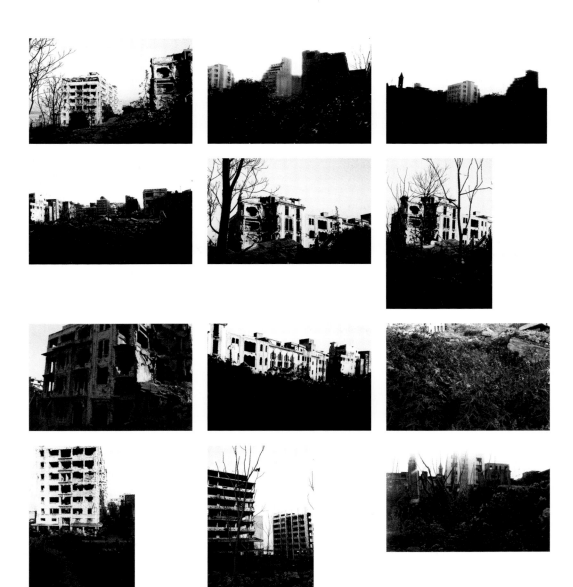

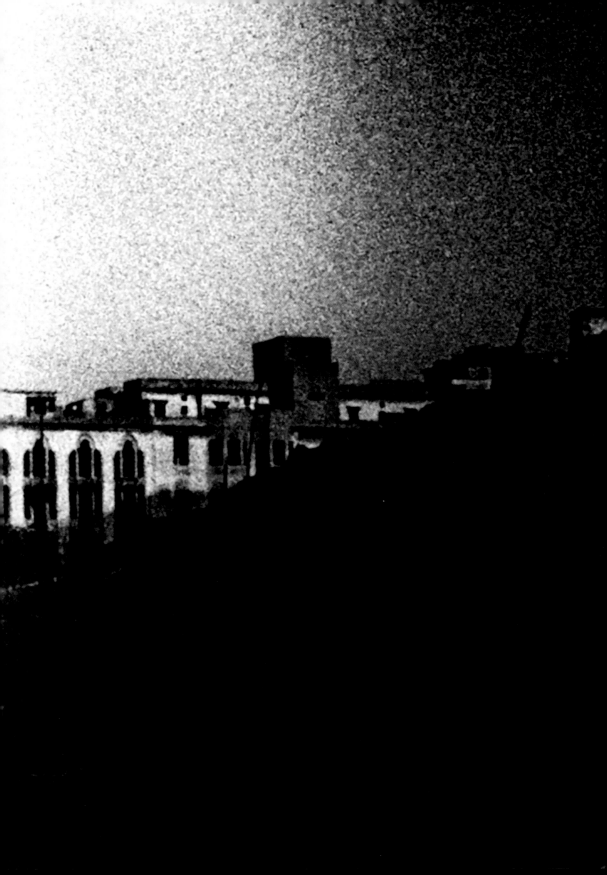

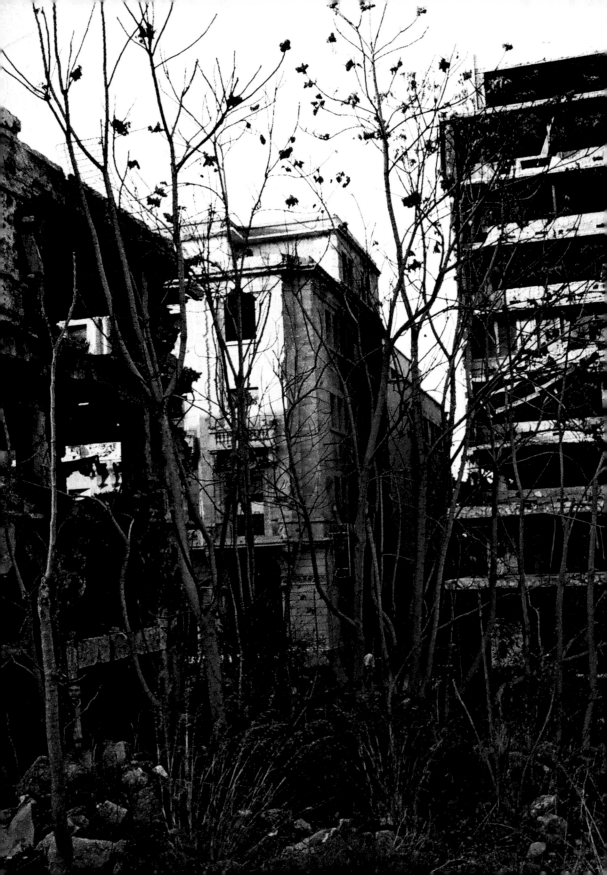

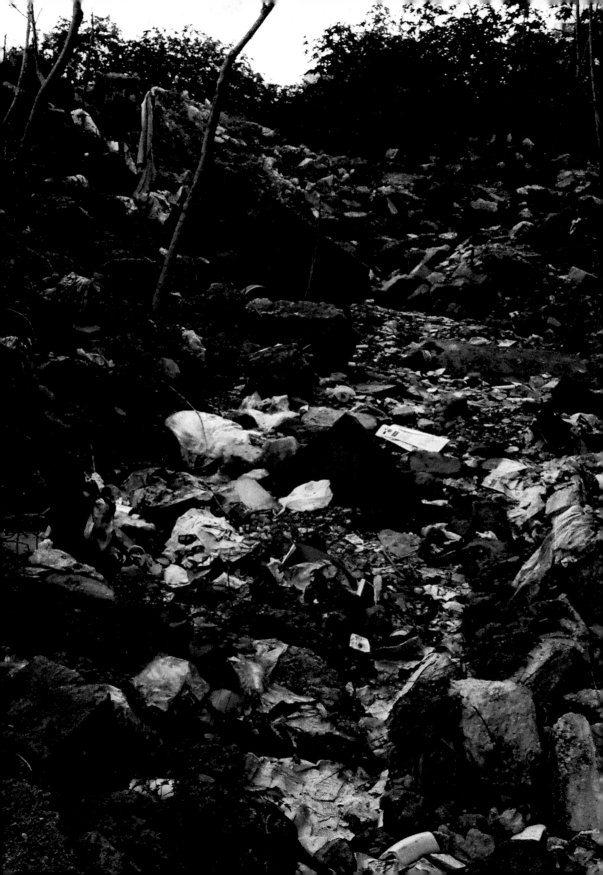

LAMIA JOREIGE
HERE AND PERHAPS ELSEWHERE

Below, opposite, and on following pages:
Lamia Joreige, *Here and Perhaps Elsewhere*, 2003.
Video stills.

What are we left with from happy or dramatic experiences such as love and war? What do we retain from these events? Remembrances which are more or less clear, feelings which are more or less strong, impressions which are more or less blurred, but mainly obscure areas. They are obscured owing to the mechanism of memory itself, to its distortions and the possibility, even the necessity, that human beings will forget. They are obscure owing to the fact that assembling all the testimonies and documents relating to past events is an impossible task. Jalal Toufic eloquently expresses this in his comments on William Blake's *Auguries of Innocence* (1803) : "I have no time to remember the event as I have yet to explore and exhaust it."

I find myself caught in a tension between the temptation and even the necessity of recounting that history, and the impossibility of fully accessing it.

Some facts, dramas and experiences will never reach us and will remain unspoken, buried. We will never be able to witness their existence, but only presume that they are there, yet missing. So history appears to be missing and becomes subjective stories, stories in the first person. An immeasurable loss of words, images and sounds, the magnitude and nature of which we will never know.

As history escapes us, only fragments remain, words and images; each fragment carries its own memory and its whole history. These fragments are memory and oblivion at the same time, parts of an incomplete whole and assembled subsequently.

Rearranged and re-interpreted, they border fiction.

Similarly to the mechanism of memory, my work attempts to collect, record, erase, invent, forget, capture, miss and divert. I say, attempts, because in all my work, I point out the impossibility of accessing a complete narrative, thus underlining the loss, the gaps of memory and history. By creating a device through which I assemble and accumulate documentary and fictional narratives, I hope to restore an essential speech.

To make visible and audible speech that has been willingly or unwillingly concealed or simply ignored. Essential, because this speech is symptomatic of a peculiar period of our history; essential also because, even when it becomes fictitious, this speech is evidence of intense and rare human experiences which, even if related to a specific context, attain a universal dimension. The diversity of the many stories recounted, their accumulation and unequal repetition link each personal experience to the collective one, making difficult if not impossible the idea of a unique truth.

During the Lebanese civil war, thousands of people disappeared. In most circumstances, the bodies were not found and the circumstances of their disappearance are not certain.

In the documentary *Here and Perhaps Elsewhere*, I accumulate a diversity of narratives, recorded along my journey through what used to be the dividing line between East and West Beirut, and where militias set up their checkpoints, the scenes of many kidnappings, and crimes. By asking each inhabitant I encounter if he or she knows someone that has been kidnapped here during the war, I trigger the process of memory, and reveal the immensity of this drama, the presence of war and its prevalence in language and various discourses. As I cross town and discover places laden with history, I draw a personal map of this city.

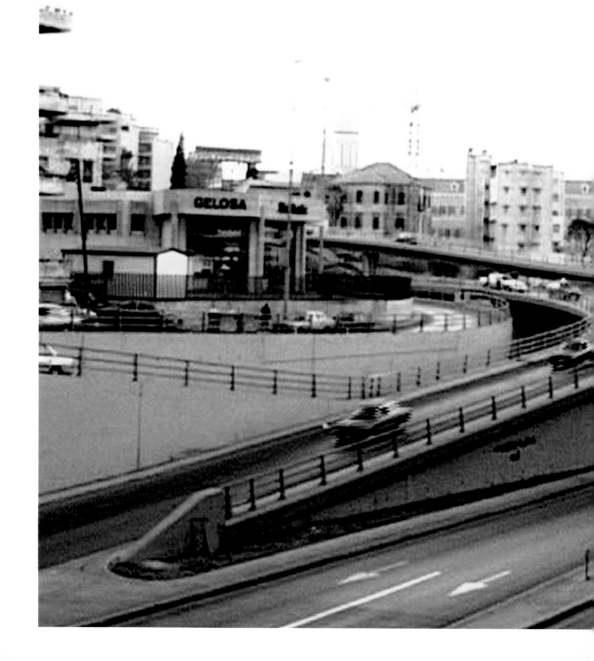

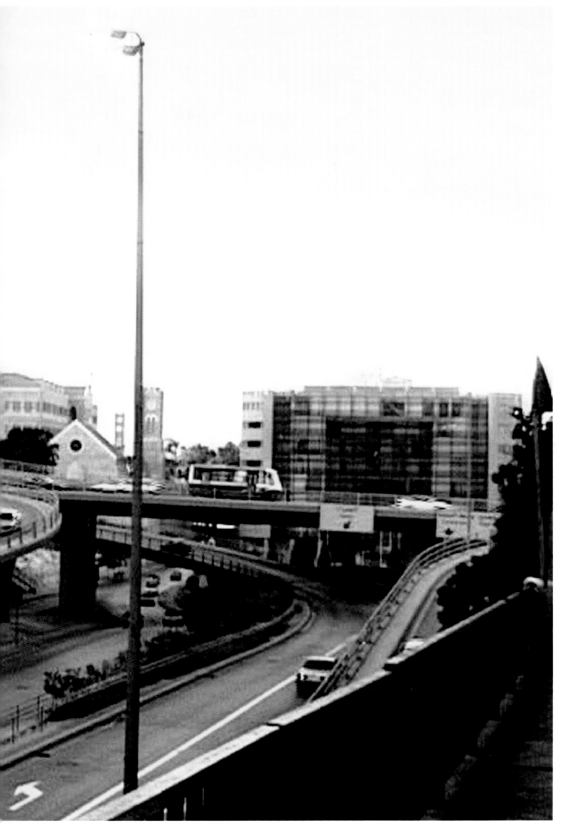

Below and on following pages:
Joana Hadjithomas and Khalil Joreige, *Distracted Bullets,*
Symptomatic Video Number 1, 2005.
Film stills.

JOANA HADJITHOMAS
KHALIL JOREIGE
DISTRACTED BULLETS,
SYMPTOMATIC VIDEO NUMBER I

"Distracted bullet" is a literal translation of the Arabic term "Rassassa taycheh", i.e. stray bullet. The Latin etymology of distraction, "distrahere", means pulling in various directions. Apart from distraction, other connotations can be found: disorientation, panic, dispersion (or scattering), diversion.

The installation consists of five panoramic views of Beirut on the occasion of events celebrated by fireworks and shooting. The noise of fireworks mingles with the sound of firearms. Where do the firearms come from? In 1994, militiamen turned in their heavy and light armament, and were authorised to keep one firearm in exchange for another which they relinquished. On some occasions, the firearms come out, are used, then put away until the next occasion.

Before our eyes, Beirut is aflame with the fires of victory. The sounds of the fireworks and firearms, their quality, their orientation, make it possible to establish a topography of the town and its divisions: the parts of the town which joyfully celebrate and those which remain silent in the face of that same event.

The sound of the installation determines the position of the spectator, that of the person filming, and the nature and context of the political event.

A brief history of the 5 events appearing in the video:

September 13, 2003: The Feast
of the Cross, Beit Mery, Metn area

Fireworks go off everywhere, an explosion of fireworks, church bells ring, prayers arise, an end-of-the-world atmosphere. No camera is available, we knock at the neighbours' door. One of them l ends us his small Hi 8. We film throughout the night.

September 3, 2004: Emile Lahoud has
been re-elected President of the Republic

Beirut, right before our eyes, is aflame with the "fires of victory"; the event was expected, the camera is ready. The fireworks begin early, at sunset, and go on through the night. A certain type of fireworks, concentrated, organized by the borough

councils (municipalities) rather than due to individual and popular initiatives.

December 31, 2004: New Year's eve

Beirut, under our eyes, is afire, there is a muffled, continuous sound. At midnight, fireworks burst out. Different sounds are heard, firearms, many firearms going off everywhere. All over Beirut, everyone is at it. From our windows, we see more clearly the Christian district, but can hear the whole town.

June 28, 2005: Nabih Berri is re-elected
as Speaker of the Parliament

As if to counterbalance the negative feelings this election produces, Beirut is full of rounds of celebratory machine gun fire; bullets are raining all over the place. 3 people are killed and 7 wounded that day. We film during the night. From where we are the town seems silent; a small part of it is still "celebrating", but more discreetly. We cannot embrace the whole town, the perspective is warped.

July 26, 2005: Samir Geagea, head of the
Lebanese Forces, is released from prison
after 11 years in jail

Before us, part of the Christian district of Beirut is rejoicing. The neighbour from whom we borrowed the Hi 8 camera on the Feast of the Cross, two years ago, brings out his machine gun to celebrate. He starts firing round after round, with short interruptions, and goes on and on for long minutes; then for long, very long hours.

Watching Beirut afire, we wonder how many people, who were happy to survive the war, became the victims of stray bullets during the various festivities? Festivities for which the use of firearms is a must: weddings, graduations, elections, re-elections, religious feasts.

We decide to research the subject and entrust it to Adel Nassar, a poet and writer. Adel visits the main Lebanese newspapers, digs into the archives, reads and photocopies certain documents but his findings are scarce: a few incidents which go back mainly to the Israeli occupation of South Lebanon with its allied militia, the Army of South Lebanon. For example, Al

Safir, in its edition dated 4 January, announced that a citizen had been wounded during the celebrations of New Year's eve by the Army of South Lebanon.

Finally, Adel realises that although some people are killed by stray bullets every year, such news is seldom published; either because the regional correspondent does not always report the case (he might find himself in a difficult situation), or because at the time it occurs, the information does not have enough weight to become "news".

Between 1994, when the militia were disarmed, and 2005, when this text was written, the newspaper *An-Nahar* registered 5458 "security incidents", involving weapons and often fatal accidents. But in the same *An-Nahar* database, only 15 events were published under the heading "stray bullets".

However, Adel managed to dig out certain events. Following the celebrations of New Year's eve 2005, all the newspapers mentioned that Rafic Hariri's plane, stationed on the airport tarmac, was hit by stray bullets. But the death of Yusra Khalaf Nasrat, who was killed by a stray bullet in Burj al Barajneh, the Beirut suburb bordering the airport, and who sis considered by her family as an "unknown martyr", was never reported anywhere.

How and why does an event become a "document"? Does individual history influence collective history?

Were these parallel events considered too anecdotal for their imprint to appear in the archives of history? Is it the place we are in which determines our knowledge? How do we keep track of these stories held secret?

Beirut Unbound
Suzanne Cotter

1 For a full and compelling account of the civil war in Lebanon, see Robert Fisk, *Pity the Nation. Lebanon at War*, Oxford University Press, 3rd edn., 2001.

2 In April 2005 the Syrian army withdrew from Lebanon after 29 years of sustained presence in Lebanon. For a lucid and compelling synopsis of the situation leading up to and following the assassination of Hariri on 14 February 2005, see Charles Glass, "An Assassin's Land. Charles Glass in Lebanon", *London Review of Books*, 4 August 2005, pp. 15–18.

3 See the special section on art and politics in America in *Artforum*, September, 2004, to name one of the more prominent art journals engaging this discussion.

Politics tends to dominate discussions with artists in Beirut; as do attempts to wind one's way through the labyrinthine history of the civil war and the city's reconstruction in the post-war period.[1] I arrived in Beirut at four in the morning in early April 2005 just three weeks after a massive car bomb had killed the Lebanese Prime Minister, Rafik Hariri. In the days after the explosion and in the weeks that followed, hundreds of thousands of people from every denomination and social group had been gathering in Martyrs' Square in the centre of Beirut to pay their respects at the tomb of the murdered politician lying in state and to stage mass demonstrations in protest at the continued presence of Syrian forces in Lebanon.[2]

Equally striking in Beirut is the apparent absence of any structure or attitude that might equate with contemporary art practice and its diffusion as we know it in Britain. In Beirut, there are no contemporary art museums, no major art prizes, and no art fairs mobbed by huge crowds of people. In short, there is no real public for contemporary art to speak of; certainly not on any significant scale, with the exception of what appears to be the beginnings of a small group of collectors who frequent the recently opened gallery Sfeir Semler in the old Karantina area of the city. Instead, networks of artists, writers, performers and film-makers run independent spaces and organise events and small festivals where work can be presented for short periods. Their approach is as much a response to the lack of dedicated spaces as it is to the strict censorship laws applied to all forms of public expression in Lebanon. The apparent urgency of work produced in this context reinforces the paradoxical sense of privilege for many artists who, while keeping their day jobs working in the universities, newspapers and television stations, remain unfettered by the cultural and economic politics of public institutions and the market with which we are familiar elsewhere.

Conversations with artists in Beirut are infused with scepticism, irony and a tangible air of defiance. An absence of discernible boundaries between different forms of practice is part of the air of reticence and refusal which characterises the attitudes of many. Architects make conceptual artworks; artists write books; photographers give readings and performances and performers create archives. The spirit of authorship, too, is subverted by a tendency towards collective practices and collaborative projects. The mix is strategic and necessary. This sense of the barely visible that pervades is in strict opposition to and in tension with the artists' explicit commitment to communicating the Beirut they share with its inhabitants.

At a time when artists, curators and writers have sought to re-ignite discussions around art and its relationship to contemporary politics,[3] the activities of artists coming out of Beirut suggest new and more urgent frames of reference. These artists, many of whom work between Beirut and Paris, Berlin, New York or London, while informed by critical practices in photography, film, performance and conceptual art, confront us with a new set of possible frameworks for art in contexts of resistance.

Mapping space

The idea of mapping space is perhaps one of the most useful tools for trying to define the nature of the varied forms of practice coming out of Beirut. It is less a case of defining the limits of a terrain or territory than of creating a cartography that might trace or signal some of the complex contours and layers, not only of the city in its physical, confessional and social divisions; but also of individual subjectivity as it is shaped by memory and recollection, and by individual and collective hopes and aspirations. Lamia Joreige records

her walk through Beirut along the former Green Line as she interviews residents along the way about people who went "missing" during the war. Her documentary-style video *Here and Perhaps Elsewhere*, 2003 (pp. 18–21), is a journey through the as yet unresolved space of memory, loss, suspicion and wilful forgetfulness of times too painful, or too futile, to recall. Joana Hadjithomas and Khalil Joreige's video installation, *Distracted Bullets, Symptomatic Video Number 1*, 2005 (pp. 22–4), maps the city as a distribution of intensities on the occasion of different religious and civic celebrations.

Ali Cherri reconfigures the city as a mosaic of fragmentary parts in his video montage *Un Cercle autour du Soleil* (*Circle Around the Sun*), 2005 (pp. 102–3); tracing the contours of the city with his camera as one might outline the anatomy of a body. The outward appearance of buildings, overpasses and main roads becomes the skeleton, the arteries and the skin of an organism that retains memories, musings and disembodied associations. Extracts from Yukio Mishima's memoir about self-realisation, *Sun and Steel* (1968), which serves as a soundtrack to the video, suggest the artist's identification with the city as a state of mind, whereas Ziad Abillama's insistent questioning of his fellow citizens during the mass demonstrations following Rafik Hariri's death in his video *Pourquoi n'Arrêtes-tu pas de Mourir?* (*Why Don't You Stop Dying?*), 2005 (p. 72–3), circumscribes a space in the future as it exists in the minds of Beirut's inhabitants.

Gilbert Hage's photographic project *Tout un Chacun* (*Each and Everyone*), 2005 (pp. 41–3) also maps a Beirut for whom confessional belonging informs the realm of the political as much as the personal and the social. His series of photographs of people standing at the base of the Monument to the Martyrs captures a slice of the city's multi-confessional population through simple, repeatable snapshots at an exceptional moment of collective mobilisation that transcends the politics of sectarian difference.

In approach also, the creation of multiple interconnected networks of artists, writers, film-makers, architects and others reflects a re-mapping or alternative mapping of Beirut that creates free zones of thought and expression. Talking about the collaborative nature of much of the work produced in the late 1990s and early 2000s, Walid Raad has explained that the very possibility of meeting people from different parts of the city was in itself a revelation after years of not being able to move beyond a particular neighbourhood.[4] This collaborative re-zoning of the artistic realm has also been influenced by what Jalal Toufic has described as "a community between strangers", which emerged in the post-war years. As Toufic explains:

> Lebanon, which due to the long civil war and the invasions it suffered as well as for other reasons has a significant number of artist and writers abroad, is a privileged site for thinking the community in general and the artistic and literary community specifically, for the latter is formed not through its members' exposure to and subsequent discussion of each other's works (which produces fashions) but through this concordance around anomalous subjects, symptoms of the culture with which they are dealing.[5]

In his book *Forthcoming*, which he completed in 1999, Toufic imagined a situation in which a Lebanese photographer working in Beirut during the civil war "had become used to viewing things at the speed of war" to the extent that, after the war, he stopped taking photographs so he could readjust to viewing things "at the rhythm of peace". When he returned to photography several years later, the photographer found that, when outside of Lebanon, he could once again take classically composed

4 In conversation, October 2005.
5 Jalal Toufic, *Two or Three Things I'm Dying to Tell You*, The Post-Apollo Press, Sausalito, California, 2005, p. 114

6 Ibid., p. 113.
7 See the artists' account of this work., p. 77 above.
8 See Jalal Toufic's book (Vampires). An Uneasy Essay on the Undead in Film, The Post-Apollo Press, Sausalito, California, 2003 (revised and expanded edition).
9 Jalal Toufic, "Ruins", Tamáss: Contemporary Arab Representations: Beirut/Lebanon I, Fundació Antoni Tàpies, Barcelona, 2002, pp. 26–39.
10 Ibid.
11 In conversation with the artist, Berlin, January 2006.

photographs. However, when he tried to photograph in Lebanon again, he was suffering from what Toufic describes as "a withdrawal of tradition": his photographs "still looked like they were taken by a photographer lacking time to aim ... compositions haphazard and focus almost always off".[6]

At the same time as Toufic's story was being published, the artists and film-makers Joana Hadjithomas and Khalil Joreige were developing their conceptual project *Wonder Beirut*, which addressed the idea of the latent or dormant image. In their project, another fictitious photographer, Abdallah Farah, amasses undeveloped film rolls which contain images of daily life which have never been developed. The details of each photograph, the date, the time of day, the subject, were, nevertheless, meticulously noted in the photographer's notebook. As with Toufic's photographer, Farah's decision not to develop his photographs constitutes a form of withdrawal of tradition, in this case the possibility of creating lasting images of a reality that is too traumatic to express.

A second element of *Wonder Beirut* includes a set of eighteen colour postcards in which the photographs, taken, we are told, by Farah, have been subject to varying degrees of immolation (pp. 76–80). The photographs, of the most beautiful tourist sites in and around Beirut, were taken in 1968 for a calendar to be published the following year. Three years after the outbreak of civil war, and the destruction of the photographic studio where he had worked, Farah began to burn his salvaged negatives from years before, little by little, in an attempt to match the image with the destruction that was going on around him.[7]

The series of black-and-white photographs that form *Summer 88*, 2006 (pp. 11–17), taken by Paola Yacoub as she accompanied a photojournalist around a war-torn Beirut, also brings to mind the idea of a withdrawal of tradition. These apparently aimless photographs of bare trees and desolate piles of rubble occurring against a backdrop of spectacular devastation suggest, if not a refusal of certain realities, a trance-like disregard. Suggesting a breach of engagement with the main event, Yacoub's approach opts for casual detours into the non-events of places and things on the peripheries of the war zone. The lack of focus and slightly off-kilter framing bring to mind Toufic's fictional photographer. They also hint at a condition of altered states, a withdrawal of reality; something Toufic, again, has described as "vampiric".[8] As he notes: "In Beirut *some* features of 'the real' must be fictionalised to be thought."[9]

Ghostly expressions

Vampires, ghosts, zombies, labyrinths and ruins: these are all terms that recur in conversations with artists working out of Beirut. In his writings, Toufic suggests that the absence of ghost stories in contemporary Lebanese fiction is due to a post-traumatic amnesia that affects not only the living but also the dead.[10] For Toufic, the traumas suffered by many have have been so severe that even the dead are affected and are incapable of returning as ghosts. Yacoub's rediscovery of the contact sheets from her 1998 photograps in 2006 when she moved to a new studio in Berlin with Michel Lasserre suggests a re-addressing of this position of amnesia. Yacoub explained that she had not been able to look at these prints objectively since they were made, having put them in a box which she only opened on unpacking her studio some eighteen years later.[11] And yet, it seems clear that these rather modest prints lay at the base of all of her and Lasserre's subsequent photographic projects, in which the incidental,

the detail and "the routine" serve as markers for situations redolent with association.

Yacoub and Lasserre have suggested "that the city is expressive. It is carried away by ... events and only takes on meaning with them."[12] The Holiday Inn, the Beirut Hilton and a few modernist tower blocks, some never completed since the outbreak of the war in 1975, stand as monuments to the city's not so distant past. Others, like the Phoenicia Hotel — a symbol of opulent modernity worthy of a Hollywood film in 1961 when it first opened — retain the aura of past events despite their gleaming make-over in the last ten years. Toufic, again, describes "the site-specificity of Beirut" as "the labyrinthine space-time of its ruins", declaring that the redevelopment of the city centre, of which Martyrs' Square occupies a central position, equates to "war on the traces of war".[13]

Bernard Khoury's "architecture of entertainment" offers a provocative response to the notion of amnesia. His projects refer as much to the conflict of Beirut's past as to the unstable conditions of living in the Middle East. Working in this context, in which the idea of duration is constantly redefined, Khoury sees his projects for nightclubs, restaurants and shopping malls as "unaccountable, unthreatening and temporary", an attitude reflected in his comment: "Gehry and Hadid are committed to form. I am committed to doubt and uncertainty."[14] The architect of numerous restaurants, nightclubs and private residences in Beirut since the late 1990s, Khoury draws on a language of mutability, impermanence and a certain confrontational fetishism in his choice of materials, and sites.

His nightclub *B018* (pp. 97–101), built in 1998 as a temporary structure, is an act of provocation that has been readily embraced by Beirut after dark. The site of the club, in the old quarantine area of the port, and in view of the Sleep Comfort building — known to those who lived through the war as a place where horrendous tortures were carried out — is redolent with ghostly presence. Previously a refugee camp, first for Armenians in the 1920s and 1930s, and then for Palestinians and Kurds and poverty-stricken Lebanese, many of whom were massacred by the Christian Phalangist Militia in 1976, the site was a desolate vacant lot rumoured to contain mass graves for the many "missing".[15] The club was conceived as a bunker-like structure, set deep into the ground so that no superstructure is visible. Cars arrive from the adjacent motorway and park around the site in a semicircular arrangement. The entrance down dark metal stairs brings to mind the entrance to a tomb. The interiors are furnished with chairs lined with purple velvet and that open out like coffins. Framed black-and-white photographs of musical icons such as Josephine Baker and Charlie Parker and Cairo singer Um Kalthoum sit on the low-lying wooden tables. A spectacular sliding roof opens the club to the night sky and further enhances the idea of some Dantesque underworld in which dancing bodies find escape in a delirious present.

Living the present

Many artists from Beirut talk of its fragility and of the challenges of reflecting on a present haunted by the past and overshadowed by an uncertain future. Jalal Toufic's video work explores memory as indelibly linked to traumatic events but also as a phantom of life. In his multi-channel installation, *Mother and Son: A Tribute to Alexander Sokurov*, 2006 (p. 46), Toufic uses the medium of film to reveal a play of doubles between memory and amnesia and between life and death. The installation includes

12 Paola Yacoub, Michel Lasserre, *Beirut is a Magnificent City: Synoptic Pictures*, Fundació Antoni Tàpies, Barcelona, 2003, p. 102.
13 Jalal Toufic, "Ruins", op. cit.
14 In conversation with the author, Beirut, September 2005.
15 More than 18,000 people in Lebanon are still considered missing since the civil war.

extracts from Alfred Hitchcock's *Psycho* and Sokurov's *Mother and Child*, shown as two distinct pieces of footage. A third video, *A Special Effect Termed "Time", or Filming Death at Work*, consists of footage shot by Toufic of his young nephew during the first three years of his life. The question that is posed is whether, in showing his nephew the recordings at a later time, he would be imposing a state of premature death, for in watching time pass in his earlier life, he would lose time in his present one.

Articulating states of contemporary subjectivity is a preoccupation for many artists. Tony Chakar asks whether art "can root itself and find its legitimacy in the present" when the terms of that present, in Beirut and elsewhere in the Middle East, are caught between polarities not only of history and memory, but of East and West and their respective associations with tradition and modernity.[16] Walid Sadek has remarked that "to remain in Beirut today requires a marked resilience in travelling the circuitous complexity of a city where the roaming of artistic intent is preceded and overlapped by the murderous roaming of political speech."[17] In "Notes for a Conversation", an introduction to *File: Public Time* produced by Sadek with writer Bilal Khbeiz and poet Fadi Abdallah following the assassination of Rafik Hariri, they write: "Upon that event, the city entered a time that was not its own. Rising each morning with the world watching, the inhabitants realised, with the bitter belatedness of the deceived, that entering such a time was more oppressive than the event itself. What befell them was a public time they could not claim as theirs."[18] This pronouncement of what at first seems a rather pessimistic view of events is, in fact, a means of articulating a space in which questions of the future might be addressed in a more openly questioning public arena.

The recent work of Sadek suggests the impossibility of imagining a future that, for many, has been achieved in the past. In *Love is Blind*, 2006 (p. 65), Sadek draws on the biography of one of Beirut's best-known modern painters, Moustafa Farroukh, who came to fame in the the decades that preceded Lebanon's independence in 1943.[19] The texts in Sadek's work are labels of paintings made by Farroukh of some of the most picturesque sites of the city and surrounding country side. Written in Arabic and in English, they are accompanied by small texts, also in Arabic, written by Sadek, and applied directly to the wall above the wall labels. Labels and texts are placed at a distance that corresponds to the dimensions of the paintings they describe. In its pared-down form and its refined poetry, of which the duality between English and Arabic languages and scripts are an essential part, *Love is Blind* confronts the viewer with an absent image; a limbo of possible worlds but which is, in fact, no place at all.

Sadek's eloquent denial of imagery points towards preoccupations shared by other artists coming out of Beirut; in particular, a resort to anecdote and a mistrust of the image as reliable document of history. The "anecdote" as counter narrative to dominant forms of representation is fundamental to the work of Tony Chakar as it is to the work of Joana Hadjithomas and Khalil Joreige. Trained as an architect, and professor in the department of architecture at the Académie Libanaise des Beaux Arts (ALBA), many of Chakar's projects have sought to redefine the language of built space beyond the conventions of plan, elevation and the map. In his recent installation *A Window to the World*, 2005 (pp. 54–6), Chakar replaces the conventional language of delimiting domestic space with a "spoken architecture" consisting of the descriptive vernacular of habit and association.

16 Tony Chakar, "The Present Postponed", *Untitled*, no. 35, Summer 2005.
17 Walid Sadek, "Contemporary Arab Representations", in *Dreams and Conflicts: The Dictatorship of the Viewer*, 50th Venice Biennale, 2003, p. 293.
18 *File: Public Time*, Bilal Khbeiz, Fadi Abdallah, Walid Sadek, *Homeworks III*, 2005. The authors will present extracts from their file at PUBLIC TIME: A SYMPOSIUM organised as part of *Out of Beirut* at the Maison Française, Oxford, on 26 May 2006.
19 The official end of the French Mandate in Lebanon and Greater Syria is recognised as 22 November 1943. See Samir Kassir, *Histoire de Beyrouth*, Fayard, 2003, pp. 391–412.

In his study with Naji Assi and their students at ALBA of a poor working-class suburb of Beirut, Rouwaysset, inhabited by mostly Lebanese Shiites with a minority of Christian and Syrian workers, Chakar and Assi attempted to map the living environment of a residential area in constant flux. Their observations are of restlessness and a mutually imposed violence as windows are progressively blocked, corridors and makeshift structures are installed for the neighbourhood's growing population. Their conclusion is that areas such as Rouwaysset can only be defined by the vernacular that had developed out of its specific conditions — conditions that are neither defined by nor look to Beirut but instead structure themselves within a dynamic of instability and improvisation.[20]

Joana Hadjithomas and Khalil Joreige embrace the anecdotal as a means of re-appropriating history. In their documentary videos and installations, they look to bring to light the stories that accompany the so-called "main events", but which are rarely, if ever, the primary focus of discussion. Their intention, as they have stated, is not to create metaphors for larger situations, but to stay within the realm of the minor and the detail, and to resist the spectacular in all its forms. In their "symptomatic" video *Distracted Bullets* (pp. 22–4), the artists document, from a distance, local fireworks and sounds of gunfire that form part of neighbourhood celebrations. The distracted bullets referred to in the title relate to the wayward bullets which have killed people as a result being fired in the air on these occasions and which are only ever reported at the level of local news. In discerning the different sounds and flashes of fireworks and guns in the video, the viewer becomes sensitised to a whole series of sub-narratives and nuances in the way different parts of the city express and thus define it. Hadjithomas's and Joreige's interest in bringing to the surface the so-called minor narratives of sub-plots that inform and shape events on the level of the everyday and the singular also reflects the more personal and, for many, urgent question posed by the inhabitants of Beirut: How does one say "I am" without the weight of history, community and family?[21] How is one inscribed in the here and now?

Disrupting the image

The inscription of the personal in relation to "events", by way of the photographic document and the archive, is one of the most compelling and consistently interrogated forms used by artists coming out of Beirut. Akram Zaatari has produced an extensive body of film and photographic works based on the personal experiences of war. His large photographic panorama *June 6, 1982*, 2003–6 is based on his own experience as a child of sixteen of the Israeli invasion of southern Lebanon. The work is made from photographs he took from the balcony of his home on the first day of air strikes. For Zaatari, this moment marked the beginning of his interest in photography: "As a child, I used to be fascinated by the site of air raids, and thought of them as the ultimate fireworks; real fireworks; real threats. They were shots of adrenaline. That was how I started taking pictures."[22] He describes his impression of a Syrian plane exploding in the sky after being hit by a missile from an Israeli fighter plane as "one of those things you never forget. That was when I decided to bring out the camera whenever I heard the sound of planes with a view to capturing these ephemeral spectacles."[23] Returning to these photographs more than twenty years after the event, Zaatari's enhancement of the image to the point of extreme aestheticisation signals the spectacular nature of these

20 For a full description of the research and the project, see Tony Chakar, Najar Assi, *Traces of Life*, produced by the Sharjah Biennial, 2003.

21 In conversation with the artist, London, October 2005.

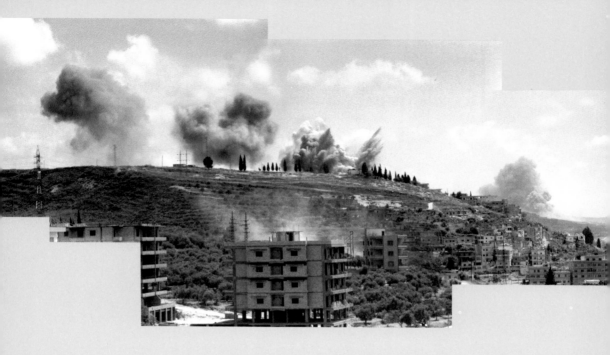

Above: Akram Zaatari, June 6th, 1982, 2003-2009. Digital print.

displays of destructive force and the "absolute boredom" he came to experience between them.

Continuing to take photographs and collect recordings "sounds that relate to wars and their news"[24], Zaatari's ongoing work *After the Blast*, 2006 (pp. 106–12) consists of photographs and recordings made in the centre of Beirut following the car bomb explosion that killed the Prime Minister in February 2005. Moving from the site of the blast as seen from the office of the Arab Image Foundation in central Beirut, of which he is director, Zaatari documented the impact of the explosion on the surrounding buildings and the build up of activity in the city over the following days as people came together to stage mass protests in Martyrs' Square. In addition to the aftermath and the protests that ensued, Zaatari took photographs of high-rise buildings and hotels with their windows and balconies boarded against the possibility of further attacks. The overall visual narrative is one of Beirut as a city responding to and preparing for violence.

Walid Raad investigates the status of the document as proof or testimony to an event. He explores how conditions of extreme violence are experienced, and the kinds of documents they produce. As he has stated: "It is not so much of what is true but what rings true to the psyche."[25] His previous work with The Atlas Group, a 14-year project between 1990 and 2004 about the contemporary history of Lebanon, consisted of an organising structure (The Atlas Group Archive), imaginary and found documents (videotapes, photographs, notebooks, and films), as well as subjects and subjects positions (Dr Fadl Fakhouri, Surveillance Office: Operator #17). With this project, Raad explored the possibilities and limits of writing the history of Lebanon by concentrating on what was said, believed, known and imagined about the wars over the past thirty years.

Raad's installations, video, photo and text works are vehicles of encryption in which distinctions of meaning and meaninglessness are

rendered indiscernible. His current work, We Can Make Rain but No One Came to Ask, 2007 (pp. 48–53), presents layers of images, texts, and different analytical registers. This work proceeds from an investigation Raad (together with Tony Chakar and Bilal Khbeiz) conducted over a 12-month period into a car bomb explosion that took place in Beirut in January 1986. Raad's research concentrated on the facts of the event and its political motives, as well as the consequences of this and other explosions on contemporary urban life in the Lebanese capital. His research uncovered photographs as well as reports, notebooks, and diagrams produced by the respected Lebanese photojournalist Georges Semerdjian, as well as by Yussef Bitar, the leading state explosives expert during the war years. Raad also produced numerous images (photographic and videographic) in an attempt to document in the present the spaces and temporalities of the neighbourhood where the 1986 explosion was detonated. The resulting work, which operates as a kind of visual zip, is an accumulation and a concatenation of details. Like a footnote running across the bottom of a page, the flowing sequence of visual information suggests a myriad of details that lie beneath the iconic and more static images that we come to associate with history as it is written.

Walid Sadek identifies in the different practices in Beirut the groundwork for an art that plays the non-artistic against the artistic and that exists, as he puts it "primarily as an intrusive activity" that "manoeuvres disruptively amidst the politics of mass appeal and the logic of consumption".[26] The actor, director and playwright Rabih Mroué disrupts and dislodges the account and the figure of the "eyewitness" in his minimal theatre performances which he has been writing, producing and performing for almost a decade. Abandoning conventions of sets, costume and character, Mroué's performances are a spare and often confrontational encounter with the audience. Performing either on his own, or with one other person, he has created what he terms a "semi-documentary" theatre in which events from daily life in Lebanon merge with narratives from different moments in time. His remarkable work Who's Afraid of Representation?, which he first performed with Lina Saneh at the Medina Theatre in Hamra Street in 2005,[27] weaves together the parallel histories of Western performance art and the civil war in Lebanon. These histories are intercut by a third narrative, that of a Beirut office worker in the late 1990s who was sentenced to death after having killed his co-workers in a murderous rampage. The testimonies of the deranged worker, as recounted by Mroué, present three different versions of the same event, and three different perspectives according to personal, sectarian and broader political motives. The performance is darkly humourous and deeply ironic in its revelation of the convenience of certain histories over others.

The work of artists from Beirut suggests a coming together of certain desires and anxieties which are central to their lives. Adopting multiple pathways, they continue to create inroads into the consciousness of their fellow inhabitants and offer persuasive arguments for how art practices operating on the peripheries of the main stream might redirect the state of things through a reframing of the given. If one is to talk of politics, it might be what Mika Hannula describes as "the politics of small gestures", in which the activity of art is marginalised in society but which nevertheless enjoys a status that gives it certain points of access to the dominant culture.[28] Similarly, the understanding of contemporaneity — the condition of being of one's time — as being constituted by a multiplicity of

26 Walid Sadek sees the foundations of this approach as being laid by the installation work of Ziad Abillama immediately following the end of the civil war. Abillama' best-known installation (Untitled, 1992) was created on a small stretch of beach north of Beirut which he cleared of rubbish and enclosed with steel posts and barbed wire, and arranged discarded machinery, weapons and remains of military operations as a sculptural installation which visitors could enter and circulate around in. See Walid Sadek, "From Excavation to Dispersion: Configurations of Installation Art In Post-War Lebanon", Tamáss, op. cit., pp. 67–81.

27 Homeworks III: A forum on Cultural Practices in the Region, Beirut, November 2005, for a comprehensive description of the performance, see Jim Quilty, "The Theatre of Torn Flesh, the Quiet Art of 'going postal'". The Daily Star, Beirut, Thursday, 24 November 2005.

28 Mika Hannula, "The Blind Leading the Naked — The Politics of Small Gestures", Art, City and Politics in an Expanding World. Writings from the 9th International Istanbul Biennial, Istanbul Foundation for Culture and Arts, 2005, pp. 184–94.

viewpoints might be read as reflected in the art from in and out of Beirut, just as Beirut mirrors the fracturing of perspectives that exist globally. The unbounded and unpredictable nature of these practices not only offers a range of eloquent articulations born out of their own specificity, it also offers an expanded framework within which we might consider current and future positions within contemporary art as a space of engagement within our own conflicted present.

Smuggling Practices into the Image of Beirut
Simon Harvey

1 Curated by Catherine David, Tamáss I: Contemporary Arab Representations, produced by Fundació Antoni Tàpies, Barcelona, 2002 and Witte de With Center for Contemporary Art, Rotterdam, 2003.

2 Michel De Certeau, The Practice of Everyday Life, University of California Press, Berkeley, 1988, p. 84.

3 In his partly autobiographical account of years of fieldwork, Tristes Tropiques, Claude Levi-Strauss ponders this elusive goal while on board ship for Brazil as he observes and attempts to describe the scene of a glorious sunset, perhaps the most clichéd image of picturesqueness. "If I could find a language in which to perpetuate those appearances, at once so unstable and so resistant to description, if it were granted to me to be able to communicate to others the phases and sequences of a unique event which would never recur in the same terms, then — so it seemed to me — I should in one go have discovered the deepest secrets of my profession." "Sunset", extract from Tristes Tropiques, Penguin, London, 1992, p. 62.

... what lay hidden in the field. What if I crossed it? Were customs officers hidden in the rye? ... I would penetrate less into a country than to the interior of an image ... apprehend directly the essence of the nation I was entering. — Jean Genet, *The Thief's Journal*

The postcard image of Lebanon is a surprisingly durable one. During the civil war touristic technicolour images of pre-war cosmopolitan Beirut were carefully stored away to be brought out again as visitors began to return during the 1990s. For a while this was a predominant image of the city, as if the war had never happened. But of course, while postcards provide a snapshot image the real image is far more complicated. The *Contemporary Arab Representations* project[1] did much to dispel this essentialisation of Beirut through the notion of the city as a creative laboratory for experimental art practices that deferred its re-presentation, or at least made it complex and sometimes obscure. However, it is possible that this problem with the image is not simply confined to Beirut. Art history now seems to be so dynamically complex as it moves into different visual cultural zones that it confounds its easy theorisation, permitting hawkers of its occasional postcard simplicity to come to the fore. Nevertheless, as Michel De Certeau has suggested, in *The Practice of Everyday Life,* in any story there can be *different* spaces in a single picture and between them there can be *"passages into something else* through twisted relations".[2] The "twisted relations" through which I want to obliquely approach both Beirut's new art practices, and indeed the experimental contortions of visual culture in general, can be equated with the idea of smuggling.

Smuggling is rarely considered as a visual cultural concern. However, in his tense description of border crossing, Jean Genet transforms what is more usually a literary image into a visual geometry. It is my contention that not only can smuggling be treated as visual culture but also that visual cultural practices can be forms of smuggling.

Genet's anxiety and paralysis at the border between Poland and Czechoslovakia, as he prepares to smuggle himself across, might well be ours as we stand at the threshold of new practices of visual culture. Genet's moment of reflection, in the midst of smuggling and from a smuggler's viewpoint, seems at first to promise clarity before, and in, this new territory for art. However, this surely must be illusory because we already know that in the shift from object-based criticism towards immersion in the artwork, and in art practices that already seem to be collaborating quite productively with critical theory, it has become more and more difficult to navigate these new fields of art practice. The expanded fields of current visual practices and cultural thought present us with infinite theoretical possibilities but with no certain means for moving critically around the "image" that we are entering.

It would be easy to dismiss Genet's viewpoint as exemplary of an old paradigm of visual culture, indeed an art historical one, fixated on the pictorial, whose goal was an ideal transcription, or interpretation and analysis of the image through what is contained within the frame or the field of vision.[3] In terms of smuggling it is equally illusory. After all, it is self-evident that the purpose and function of smuggling is neither to produce clarity (rather to remain invisible), nor to eliminate borders and thereby the profit potential in exploiting differing national

economic, cultural and social systems. On the other hand, this
is precisely the illusion of many migrants: the removal of borders
enabling direct access to the essence of the image: an attainable dream.
Nevertheless, the poise, that moment of waiting described by Genet is
also interesting. His illusion can also be taken as a challenge: How to
enter into the new fields of visual culture while simultaneously engaging
with borders, and acting between secrecy and visibility? And if invisibility,
or at least partial visibility, is to be an ally in this mobile and dynamic
passage then what kind of clarity and sense might cohere in this
obscurity? Might new imagery and new social knowledges emerge
that are not quite so mirage-like?

The insubstantiality of smuggling is something of a problem in that
it fetishises the invisible. The term smuggling has, for the most part,
functioned in critical theory only as an arch-metaphor. It conveniently
carries discourse unproblematically and invisibly across impasses and
between bodies of incompatible work. To a lesser degree the smuggling
metaphor is one that endlessly slips or is stretched so that it fails to
materialise into productive modalities: intervention, new ways of being-
in-the-world, or complex installation and assemblage.

Perhaps we should not be seeking to apprehend so directly the field
of visual cultures, to enter and understand the image. Similarly, while
suggesting that many art forms have smuggling within them, I do not
want to look too hard for it, and not solely within the boundaries of
traditional art-historical practices but rather, to shift its visual parameters.
If smuggling can do more than regulate the means and production of its
revelation, if it produces and yields effects, then it can also turn away
from the lens, scramble its sensibilities, and resist our attempts at
identification with it.

Smuggling offers a new approach where others have become stuck.
For instance, while certain practices of art theory have become all the
more taxing, demanding new accounts of border-crossing in discourses
of race, gender, space and identity, there is a danger that these discourses
themselves become a new series of customs checks.[4] Smuggling might
offer a way through these impasses, not so much as *coyote*, or guide,
but in producing contraband modalities of being-in-the-world that
embody asymmetrical viewpoints and undermine, exceed, run through,
circumvent or even evade the taxing or taxable object of study.

Many of these problematics and potentialities are immediately
relevant to the kind of practices that go to make up *Out of Beirut*.
In the conversation between Tony Chakar, Bilal Khabeiz, Walid Sadek
and Stephen Wright, there emerges a need to move beyond "picture
politics", a form of complacent imaging that assumes that in putting
political issues into images one is producing politically relevant art.[5]
As Walid Sadek states in response to the reduction of Lebanese art to a
representation of the "Arab World" or "Middle East", "Islamic World" or
"Levant", there is also an "insubordinate material presence that persists
in exceeding that same act of representation". This resonates with what
Edward Soja has called the "clandestine side of social life". This kind of
milieu has "complex symbolisms" that "… retain, if not emphasise, the
partial unknowability, the mystery and secretiveness, the non-verbal
subliminality, of spaces of representation …"[6]

I would suggest that in order to tap into the excess or unknowability
of Beirut not only are smuggling approaches necessary, but one must

4 A more positive development is that these areas of discourse have been opened out from their insular tendencies, although this has also had the side-effect, albeit liberating in itself, that we sometimes find ourselves lost in the field.

5 See below, pp. 63–4.

6 Edward Soja, *Thirdspace: Journeys to Los Angeles and Other Real and Imagined Places*, Blackwell, Oxford, 1996. p. 67.

7 Roland Barthes, "From Work to Text", *Image Music Text*, Fontana, London, 1997.
8 Michel De Certeau, *The Practice of Everyday Life*, University of California Press, Berkeley, 1988. p. 87.
9 *Non-lieu* is a departure from *milieu*. Ibid., p. 80.
10 Ibid., p. 80.
11 Ibid., pp. 72–9. De Certeau derives the idea of tightrope walking from Kant.

have a certain informal knowledge of how practices themselves can be made in contraband ways and produce contraband spaces. Many of the artworks produced for *Out of Beirut*, or prior to it by its artists, while not literally being about smuggling, are on its wavelength and pursue some of its tactics of, as De Certeau suggests, making "passages into something else".

Several of the artists have shown a subtle interdisciplinary approach to the city. For instance Paola Yacoub and Michel Lasserre have combined art, architecture and archaeology as a way of engaging with Beirut. Architect Bernard Khoury's nightclub *BO18* (built in 1998) is a stealth installation as much as a building. Roland Barthes suggested that in our inhabitation of textuality there is a perpetual demonstration rather than display.[7] Khoury's music club, in the context of Beirut's multi-textual emergence from the civil war, displays itself only in strategic fashion. It is neither about display, nor, as a building, being seen. In simulating a bunker it has no discernible façade and when open it retracts its entire roof providing an asymmetric viewpoint on the city while remaining largely invisible itself. Barthes's point about display is important. Display suggests exhibited work while Khoury's artworking, implanted on the site of a civil war no-go zone, Quarantaine, functions as a critique of the works of amnesiac developers who conveniently forget the mixed narratives that produce these central sites as communal spaces.

While developers have moved in to produce a certain type of built space, memory flows beneath in covert but occasionally demonstrative ways. Lamia Joreige, in her work *Here and Perhaps Elsewhere* (2003) has reactivated shapeless memories by asking people along the trace of the Green Line if they know of anybody who disappeared during the war. This is not simply to bring knowledge to the surface and into discursive and theoretical reckoning, De Certeau sees memory as something more artful:

> Standing in the same relation to time that an "art of war" has to manipulations of space, an art of memory develops an aptitude for always being in the others' place without possessing it …[8]

De Certeau characterises storytelling, memory work, as producing effects not objects, and in doing so effecting a displacement or alteration. In getting down to the everyday grounds of enunciation, to the "*non-lieu*" where practice is an unsuitable building material for discursive development,[9] he claims that the practices of everyday life resist appropriation to the elevated levels of discourse. *Non-lieu* is the "practice of nowhere", and well expresses not just the unhomedness of certain artworkings in Beirut but also the very guileful and tactically responsive practices of being "there and not there".[10] being *in situ* but not situated.

In part, the effectiveness of many of the artists in the exhibition resides in how they respond to some of the over-determinations of Beirut: not simply its pre- and post-conflict postcard image, but also in the war's own markers such as the Green Line. In one sense, and playing on De Certeau's characterisation of artists and storytellers as tightrope walkers subtly making minute judgements, they balance on the line, but in other ways they undermine it.[11]

As a balancing act in relation to theory, practice demonstrates one of the essential skills of smuggling: being as near to ordinary as it is possible to be while carrying out an *extra*ordinary action. Theory, or at least an "art of thinking",[12] has a number of concepts for walking this

line. Some artists, and smugglers, operate with a speed minutely variant to ordinary movement: a body, as Deleuze and Guattari say "that deviates, however slightly from its line of descent or gravity".[13] This line of *gravitas* might well be the Green line if its meaning is constructed rigidly and it is literally built upon. Barthes is also sensitive to the proximity of lines of regulation in his description of all text as paradoxical. He states that text "tries to place itself very exactly *behind* the limits of the *doxa*".[14] In other words, it draws on all literatures and a plurality of genres that work precisely on the limits of enunciation where informal texts simultaneously transgress and re-legitimate orthodox ones. Precisely the extraordinary practices of certain artists and smugglers as they negotiate their way around limits and borders.

As well as playing along the lines that draw up Beirut's new plan from its old image, artists undermine over-determinations of the war. In works such as *Missing Lebanese Wars* (1996) and *Hostage: The Bachar Tapes* (2000), Walid Raad produced performative documentary fictions that undermined some of the simplistic views of the destruction and rebuilding of Beirut as representational image. Sometimes the tactic of smuggling is to "make strange", to complexify the all too readable image. Making strange, or *ostranenie*, is an artistic strategy that derives from Russian Futurism.[15] It was taken up again during the 1970s and 1980s as a critical strategy to shake rigid concepts of representation out of their complacency. In *Distracted Bullets*, Joana Hadjithomas and Khalil Joreige's recent video work, an investigation is carried out into the incidence of death, after the war, from bullets fired into the air in celebration. This is not just a neo-historicist narrative of Beirut, but also a performative demonstration of the strangeness of knowledge. As the artists have stated, "the information does not have enough weight to become 'news'."

Smuggling would never seek this kind of publicity, but of course, art has its moment of display. It is perhaps a challenge, just as it was to step into an image of visual culture, to allow some of these contraband tactics in the production of art to come into its site of exhibition. Visual cultural theorist Irit Rogoff has conceptualised the term "the curatorial" to characterise an exhibition practice that unbinds works and ideas from dominant structures of knowledge and overly legitimating frames or environments. This would be an interdisciplinary or cross-disciplinary experiment in trafficking between what is in plain sight, what is in partial sight and what remains, tactically, invisible. It might, indeed, look and perform more like a black market than an exhibition, but like all second economies it would have a negotiable relationship with the first. As such the dynamic of the curatorial draws on tensions between formal knowledges and informal ones, between secrecy and display, and between exhibition constructions and passing contraband installations.[16]

Smuggling considered as a complex visuality takes us away from disciplines where it has figured most often (somewhat statically and only as object of study). Among these one might list social anthropology, ethnography, history and geography, although, of course, in *Out of Beirut* these approaches function perfectly well as tactics rather than as disciplinary models. The drawback with many of these forms of direct study of smuggling is that too often the mode of critical apprehension becomes something akin to customs – categorising, ordering and overly exacting. The unfolding of a social practice like smuggling in this way

12 Ibid., p. 75.
13 Ibid., p. 371.
14 Roland Barthes, *From Work to Text*, Fontana, London, 1997, pp. 157–8.
15 For more on making strange, sometimes called *Verfremdungseffeckt*, see Simon Watney "Making Strange: the Shattered Mirror", *Thinking Photography*, ed. Victor Burgin, Macmillan, London, 1982.
16 *The Curatorial and Smuggling* is a project currently in progress at Goldsmiths College, University of London.

serves only to make it invisible, paradoxically, through excessively ordered exhibiting of findings that leave us with little room for critical or creative manoeuvre. This can happen when conventionally mined archives of smuggling of the type listed above are used in the service of art practice, for instance in traditional documentary style, as mere content or subordinated to the requisites of the finished artwork. Over-exposure negates both contraband effects and empowering processes. It should be of less importance precisely where smuggling is revealed than how it both continues to reveal and to secrete itself elsewhere. Hence the site of its exhibition becomes much more variable.

This might bring us to contraband artistic tactics and strategies that move even beyond the already expansive transgressions of frame, or border of the gallery, or the disappearance of the object. The new fieldworks[17] that are appearing indicate a theory and practice beyond restrictive, limited and unimaginative deployments of smuggling in visual critical theory.[18]

Smuggling need not always be considered as specifically sited or either against, or with, anything in particular. If it is to make a stand, visuality in smuggling should be a flexible, negotiable modality, constantly mobile and transformative in terms of its viewpoints or its variable and partial visibilities. It can both be an indicator, translator, and navigational device — a reading strategy in the multiple languages and registers that make up contemporary visu al cultures — and also something as-yet-unseen and, as such, less apprehendable, instrumental and directing. Nevertheless, to my mind, smuggling is a form of active visual cultural practice and becomes as much about visibility as invisibility. Instead of simply hiding from a singular language of surveillance, smuggling must disrupt the very sense of it when it is limited to scanning given territories and predictable crossings. To really mobilise smuggling it is necessary to engage it differently — for instance not smuggling categorised as art, nor even art simply tracking smuggling, but art *as* traffic, performing as contraband. As such it strikes an attitude: it is active, a protest, makes a stand, but is at times ineffable, eludes "sense" or "sensible" mappings, and always exhibits complexity in its installation.

There are many aspects to smuggling — the clandestine performativity of the contraband object, of the trafficking subject and their incursions and excursions into, through, and out of their *milieu* for instance — that haven't been explored here, but in *Out of Beirut* some of these tactics begin to mobilise. This is just a beginning to thinking visual culture as smuggling; its real potential is in its practice rather than critical apprehension and this is where the kinds of visual cultures being practised in Beirut are of considerable relevance to it.

I would like to make a case for a more dynamic, constitutive role for smuggling in practice-theory than that posited either by metaphor or stereotyped image. Here, out of Beirut, the covert mobilities and dynamism of the city itself might be adopted in theorising and practising visual culture as smuggling.

17 *Fieldworks* was the title of a conference concerned with just such new visual cultural practices that took place in 2002 at Victoria Miro gallery in London.

18 For instance, in the context of postcolonial discourse this had invariably led to a binary construction of authority versus transgressor, or contraband bodies defined only in terms of departure from colonial models of identity.

GILBERT HAGE
TOUT UN CHACUN

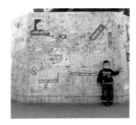

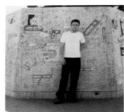
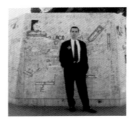

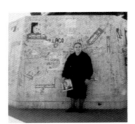
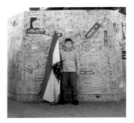

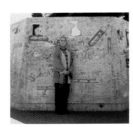

Above and on following pages:
Gilbert Hage, *Tout un Chacun*, 2005.
Ultrachrome prints.

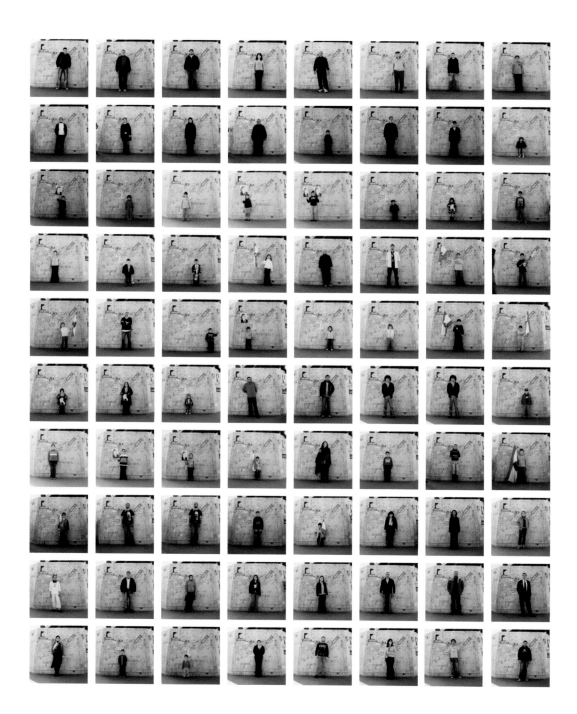

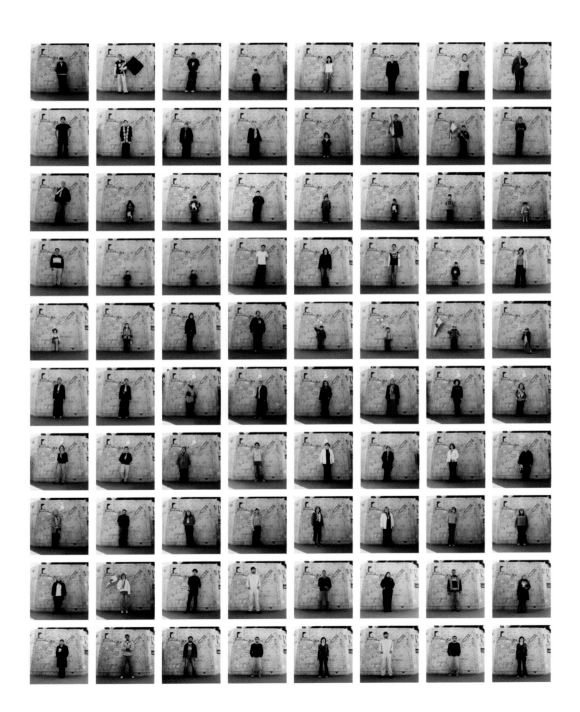

JALAL TOUFIC
MOTHER AND SON:
A TRIBUTE TO ALEXANDER SOKUROV

Production still on the set of Ghassan Salhab's feature film *The Last Man*, 2006, in which I have a short appearance in the role of a doctor of medicine.

February 2003, Lebanon: on hearing on the phone that my 63-year-old mother had severely injured her face on falling while taking a walk in Westwood, Los Angeles, I suddenly felt that this accident reached and damaged the immemorial face I must have first seen in the initial 8 months of infancy, before the constitution of chronological time[1] — for me the aging process, which has severely altered my mother's face, had not affected her immemorial face of my infancy.

Mother and Son; or, Reminder to Check with an Optometrist, 2004.

1 Jean Piaget, *The Construction of Reality in the Child*, trans. Margaret Cook , Basic Books, New York, 1954, pp. 334–5: "At the third stage [between the ages of 3–6 and 8–10 months] the child is able to perceive a sequence of events when he himself has engendered that sequence or when the before and after are related to his own activity, but if the perceived phenomena succeed each other independently of himself he disregards the order of occurrence... and thus the objective structuring of time remains impossible... The child at the present stage is not yet capable of reconstructing the history of external phenomena themselves, or of locating his own duration in that of things ..."

Jalal Toufic, *A Special Effect Termed "Time";
or, Filming Death at Work,* 2005.
Conceptual poster.

Out of Beirut 45

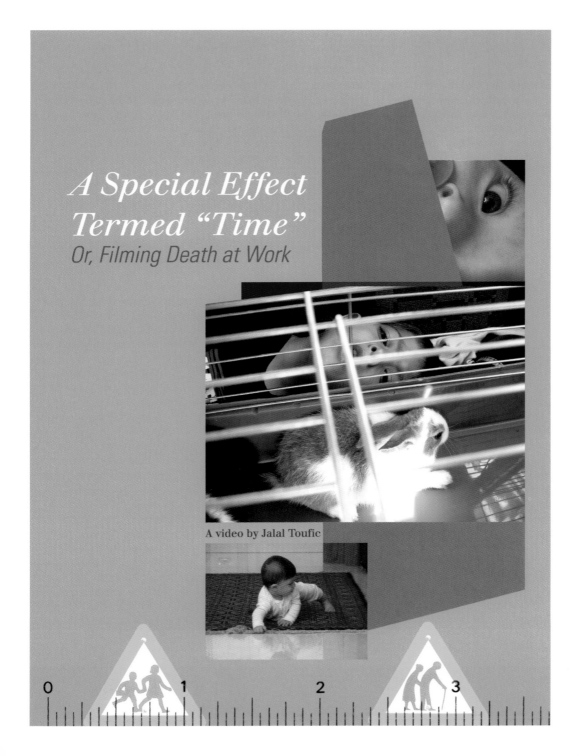

JALAL TOUFIC
MIND MY BUSINESS

Dedicated to the "M.O.B.[Minds Own Business]ist" William Burroughs

Most of the trouble in this world has been caused by folks who can't mind their own business, because they have no business of their own to mind, any more than a smallpox virus has. William Burroughs[1]

In one of Hitchcock's films, two strangers meet accidentally on a train. The first man intends to marry the woman he loves once his divorce with his unfaithful wife is finalised, and the other man hates his father. "Some people are better off dead, like your wife and my father for instance. ... Let's say that you'd like to get rid of your wife. Let's say that you had a very good reason. Now, you'll be afraid to kill her. You know why: you'll get caught. And what would trip you up? The motive. Ah! Now, here's my idea; it's so simple. Two fellows meet accidentally, like you and me. No connection between them at all, never saw each other before. Each one has somebody that he'd like to get rid of, so—they swap murders! Each fellow does the other fellow's murder, then there is nothing to connect them. Each one has murdered a total stranger." For a series of Hitchcock films (*Strangers on a Train*, 1951; *North by Northwest*, 1959; *Psycho*, 1960, etc.), I would propose the generic title: Mind My Business. If the mother figures prominently in these films, it is to a large extent because she is—if we view the matter from the perspective of the infant once he has attained a minimal sense of separation from his mother and achieved a rudimentary ego—the first stranger who has minded the protagonist's business. And it is possible that later in life, he'll wish for a repeat of this situation—no experience of being minded by someone we already know prior to his doing so (a friend, a relative ...) can reproduce that initial experience of life, being minded completely by a stranger. In Hitchcock, becoming an adult does not entail that I should mind my own business, i.e. both not interfere with the business of others and conduct attentively my personal business; but rather that I have to either have the good luck of coming across

a stranger who will replace my mother as the one who will mind my business, or else actively try to lure some stranger to do this for me. From this perspective, an infantile man is someone who still relies on the no longer appropriate person, his mother, to mind his business instead of enticing some new, appropriate stranger to do that. In *Psycho*, the sheriff tells Lila that the silhouette she saw in the house overlooking the motel where her missing sister, Marion, was last seen cannot be Norman Bates's mother, since, ten years earlier, the latter poisoned the man she was involved with when she found out that he was married, then fatally took a helping of the same stuff, Strychnine, and was buried in Greenlawn Cemetery. But in the final scene of the film, after the apprehension of Norman, and in the presence of the sheriff, who does not object to what he hears, the psychiatrist advances a different explanation of what transpired, one that he "got from the mother" of Norman. After living with her son for many years, she met a man. It seemed to Norman that she "threw him over" for that man, so he killed both of them. Since, according to the psychiatrist, "matricide is probably the most unbearable crime of all—and most unbearable to the son who commits it," Norman tried to erase the crime, at least in his own mind, first by stealing her corpse, hiding it in the fruit cellar, and treating it to preserve it, then by functioning at times as a medium for her thoughts, speech, and behaviour. And because he was pathologically jealous concerning her, he assumed that she was as jealous concerning him. When Marion arrived at the motel and Norman was perversely aroused by her, at one point peeping through a small hole in the wall at her undressing in her motel room, his "jealous mother" was provoked and "she" killed her. For my part, I prefer to consider the film's events from the perspective of the aforementioned Hitchcockian motif of minding the other's business. Having found out that the man with whom she was involved was married, the mother poisoned him and then, wanting to commit suicide but unable to do so, asked her son to kill her. Once he acquiesced and minded her business—to commit suicide—by killing her, he had to find a way to make her fulfil her side of the implicit

1 William Burroughs, *The Adding Machine: Selected Essays*, Beaver Books, New York:, 1986, p. 16.

bargain: I mind your business and you mind mine. In Hitchcock, one can never legitimately complain: *mind your own business* (as is clear in *Rear Window*, where the protagonist, a photographer with a cast leg who gazes through binoculars as well as a long-focus lens at his neighbours for much of the film, discovers a murder), since one of the motifs in Hitchcock's universe is: mind my business ... and I'll mind yours. Rather, the paradigmatic Hitchcockian complaint is Bruno's recurrent one in *Strangers on a Train*, which can be formulated thus: "I have minded your business [by killing your unfaithful wife who made an infuriating about-face, refusing to sign the divorce papers], but you have not minded mine [by not murdering my disrespectful father]!" This must also have been Norman's complaint in *Psycho* in the aftermath of his murder of his suicidal mother. Norman's weirdness is clear in his expectation that his dead mother's unfinished business will be respected, that his mother will keep her part of the implicit bargain from beyond the grave. He therefore steals her corpse, hides it in the fruit cellar, mummifies it, then begins to function at times as a medium for her thinking, speech, and behaviour so she would mind his business. By repeatedly stabbing Marion in the shower, the "mother" minded her son's business, revealing thus that his desire is less to peep at his young female motel guest than to stab her to death. There is thus a major difference between Norman's murder of his mother, and his separate murders of the three young women at his motel: Norman did the first at the request of, and therefore for his (depressed) mother; but he committed the subsequent three murders, through the detour of his "mother," to assuage his own desire. In *Vertigo*, Scottie is frustrated not because Madeleine's husband has staged his desire for him but because he does not continue to do so once he has reached his own goal: to kill his wife and inherit her fortune. When exasperated Scottie tells Judy, "What happened to you? Did he ditch you? ... What a shame!", he is also thinking about himself, since he feels that he too was discarded by the husband, a stranger who proved that he can mind Scottie's desire better that he himself can: "He made you over just like I

made you over, *only better*. Not only the clothes and the hair, but the looks, the manner and the words, and those beautiful phony trances." Hitchcock's universe is thus not a paranoid one: Scottie's problem is not that someone is constructing, unbeknownst to him, a fictionalised world for him; but rather that the other, having reached his goal, will stop doing so. In *North by Northwest*, Roger Thornhill, a Manhattan advertising executive, is mistaken by a ring of spies headed by Phillip Vandamm for George Kaplan, a non-existent decoy created by the United States Intelligence Agency to divert suspicion from an actual agent. In order to create a convincing decoy, the Intelligence Agency established elaborate behaviour patterns for Kaplan, moved his prop belongings in and out of hotel rooms, etc. When one of the members of the Intelligence team in charge of handling the case asks the others: "Does anyone know this Thornhill?" The others at the meeting answer negatively. "What are we going to do?" "Do?" "About Mr. Thornhill?" "We do nothing!" ... "We can't sit back calmly and wait to see who kills him first! Vandamm and company or the police?" "What can we do to save him without endangering our agent?" Is it true that they do nothing? No, soon after, they arrange for a special agent to meet Thornhill on the train; the meeting triggers a love affair between the two. Thus they ended up providing him, a stranger to them, with a lover, in this manner minding his business. In Hitchcock, the other has no right to place me in the position of *the wrong man*, to have me taken for the perpetuator of a crime he wants done, if he does not in the process try to provide me with my deepest desire.[2]

From "The City of the Fellowship of Strangers," in Jalal Toufic's *Two or Three Things I'm Dying to Tell You*, The Post-Apollo Press, Sausalito, California, 2005, pp. 80–3.

2 From this perspective, Hitchcock's *The Wrong Man*, which is based on a true story, is an anomaly, *the wrong film*, since it shows a man unjustly mistaken for someone else *who is unaware of his existence*.

WALID RAAD
WE CAN MAKE RAIN
BUT NO ONE CAME TO ASK

Below and on following pages:
Walid Raad, *We Can Make Rain but No One Came to Ask:*
Plates 172, 237, 377, and 479, 2007.
Digital photographic prints.

990, Georges Semerdjian was a fearless photojournalist who had tirelessly chronicled the war

the past three decades. Until his retirement in 1994, Yasser Bitar was the Lebanese state's chief

ns and explosives expert, the ladi

as signed in Damascus by Elie Hobeika, representing the Lebanese Forces, Walid Jumblatt represe

rogessive Socialist Party, and Nabih Berri, representing the Amal Movement, in the presence of

TONY CHAKAR
A WINDOW TO THE WORLD

Standing in the entrance again she turned left to take the corridor leading to the bedrooms. She traversed it hurriedly and got to a small clearance from where the light was coming. That should be the sitting room, she thought; furnishing will be easy, a couple of couches should suffice, with some bookshelves where a television could be fitted. She was pacing the small space, trying to place the furniture in her mind, when, from the only window in the room, she caught a glimpse of the outside: a small garden at the back of the building, a few benches and kids playing. It was nothing, just a quick glimpse from the corner of her eye; and there was really nothing particular about the view. Why then the flow of emotions? Why this strange mood? She was feeling her eyes moving to the back of her head, showing her things that were not from her present anymore. She remembered her grandmother's house again. She was a small child and the war hadn't started yet. All the family would meet there on Sunday, and in the hot summer mornings, before the sun became too sharp, all the doors and windows were open, the floors covered with water, her mother and aunts all had brooms in their hands, their feet clad with bright coloured plastic slippers, their skirts tucked above their knees, energetically swishing the soap and water out of the wide open doors. A delightful circular movement could be felt between inside and outside, appearance and depth, energy and surface, and she was sitting there, on the sofa, surrounded by the rest of the furniture which had been lifted from the floor. How good it was to feel the house at work! A deep sense of melancholy filled the hollows in her body, especially as the thought of never regaining that feeling made it to her surface. People have forgotten how to live, how to dwell, how to stay, how to be. People have even forgotten how to die – her grandmother said that to her the day before she died. It made sense only now. The poor woman had been dragged out of her house, as if by force, and her mother and her aunts took turns in housing her. From the moment she was severed from her house, the entirety of her life evolved into the opposite of that notion of stillness that is so profoundly embedded in the act of dwelling. And she never stopped complaining about how they turned her into a nomad, a being with no place of one's own. Finally, and just ahead of her death, she told her granddaughter – a woman now – that maybe the only reason she wasn't dead yet was because she had become a nomad and had forgotten how to die. At the time, she credited the statement to nothing more than senility in her poor grandmother. Until it resurfaced now, in this new house, as an image caught from the corner of her eye. "I'm becoming crazy!" she muttered; shaking her head, while turning her back to the window overlooking the garden, and heading towards the bedroom opposite her.

Two other bedrooms stood to her right, but for whatever reason her motion channelled her into this one first. She opened the door and was pleasantly surprised: the room was spacious enough, with a window giving to the east and a glass door leading to a small balcony facing south. It had a built-in closet and a separate bathroom accessible only from within the room. This will be the master bedroom, she thought to herself; the small balcony is perfect for the morning coffee with her husband. He would be pleased. He always complained of his entrapment by that one window in their old bedroom. At least in this house he won't have an excuse to jump out of bed and out of the room the moment he wakes. She deeply believed that he never really made the room his own, that it always felt

like he was only visiting, like he was always ready to leave. But could she blame him? After all, that house was rented; and in a sense they were both only visiting. She never really thought about that while they were living there, and they did for twenty years. The notion had hit her like a rock when their landlord had come and insinuated something about them having to leave. He had told them that his son was getting married and according to the law, he had the right to give him their house. All at once she felt like a stranger in her own house. She began to look at it differently, seeing the paint peeling off the old walls, noticing how worn the furniture was, and realizing how much money would need to be spent to replace it. This was not the time for this aggravation. But when was it a good time for aggravation really? She sighed in relief. They had managed to find this house quickly enough. Now at least she wouldn't have to run into her landlord or any of his family who had been their next door neighbours for those twenty years. People they had known for twenty years had simply asked them to leave. Just like that. Property is all that matters these days. So in a sense they were really just using someone else's property. It was logical and within the owners' right to claim it; but still, a house is much more than property, much more than a quantity of square meters. You wear your house just like you wear your clothes. It becomes part of you, part of who you are, of how people see you. The owners of property don't understand that, and it is never written in the contracts for their leases. Architects don't know that either. While she was buying this house she had another argument with the architect: He was going on and on about how functional his design was and she was irritated because he spoke like doctors speak. So she tried to explain to him that a house was only a support for furniture, but he didn't understand what she was saying. He replied with his sarcastic grin, "but that's the decorator's job Madame, and I am an architect.[1] He totally missed her point, the silly man. She tried to explain the best she could. If you want a room with a warm feeling, you put a nice fluffy carpet. But to put a carpet, you'd have to build a floor. And if you wanted to add more warmth, you would clad the walls with wood, for instance. But you would have to have the walls to begin with. "These drawings you show me don't tell me anything – all I see are lines here and there and I don't understand". The poor man looked mortified, and she felt sorry for him, especially when the realtor stepped in, took him aside, and probably asked him to leave, because this is what he did, shaking his head, feeling defeated, and behaving not at all like artists who firmly believe that future generations will certainly appreciate their work; but rather like a toilet seat salesman, who while talking passionately about his work suddenly realizes that his audience is bored stiff. He felt defeated, but she didn't exactly feel victorious, only annoyed. Now she had to put up with the realtor going on and on about her not needing to worry about some stupid architect. He had a big fake smile and wore a suit, and his tie was a bit wrinkled. But she was not about to mess this deal like she did the others (at least this is what her husband told her), so she calmed down.

In any case, that was all behind her now. The house was hers and she could do with it as she pleased. She continued her tour, stepping out of the master bedroom, taking a few steps to her left and walking into the small space which distributed two rooms with their bathroom. This is perfect, she thought. The bigger of the two rooms would go to her two boys,

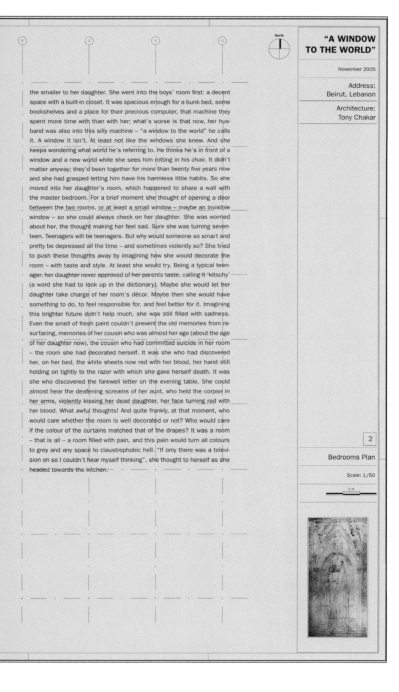

Below and following page:
Tony Chakar, *A Window to the World*, 2005. Detail.
Digital prints.

North

"A WINDOW
TO THE WORLD"

November 2005

Address:
Beirut, Lebanon

Architecture:
Tony Chakar

the smaller to her daughter. She went into the boys' room first: a decent space with a built-in closet. It was spacious enough for a bunk bed, some bookshelves and a place for their precious computer, that machine they spent more time with than with her; what's worse is that now, her husband was also into this silly machine – "a window to the world" he calls it. A window it isn't. At least not like the windows she knew. And she keeps wondering what world he's referring to. He thinks he's in front of a window and a new world while she sees him rotting in his chair. It didn't matter anyway; they'd been together for more than twenty five years now and she had grasped letting him have his harmless little habits. So she moved into her daughter's room, which happened to share a wall with the master bedroom. For a brief moment she thought of opening a door between the two rooms, or at least a small window – maybe an invisible window – so she could always check on her daughter. She was worried about her, the thought making her feel sad. Sure she was turning seventeen. Teenagers will be teenagers. But why would someone so smart and pretty be depressed all the time – and sometimes violently so? She tried to push these thoughts away by imagining how she would decorate the room – with taste and style. At least she would try. Being a typical teenager, her daughter never approved of her parents taste, calling it 'kitschy' (a word she had to look up in the dictionary). Maybe she would let her daughter take charge of her room's décor. Maybe then she would have something to do, to feel responsible for, and feel better for it. Imagining this brighter future didn't help much, she was still filled with sadness. Even the smell of fresh paint couldn't prevent the old memories from resurfacing, memories of her cousin who was almost her age (about the age of her daughter now), the cousin who had committed suicide in her room – the room she had decorated herself. It was she who had discovered her, on her bed, the white sheets now red with her blood, her hand still holding on tightly to the razor with which she gave herself death. It was she who discovered the farewell letter on the evening table. She could almost hear the deafening screams of her aunt, who held the corpse in her arms, violently kissing her dead daughter, her face turning red with her blood. What awful thoughts! And quite frankly, at that moment, who would care whether the room is well decorated or not? Who would care if the colour of the curtains matched that of the drapes? It was a room – that is all – a room filled with pain, and this pain would turn all colours to grey and any space to claustrophobic hell. "If only there was a television on so I couldn't hear myself thinking", she thought to herself as she headed towards the kitchen.

2

Bedrooms Plan

Scale: 1/50

1 m

She had to return to the bedrooms corridor to get to the kitchen. It was dark. The only natural light came from the glazed door in the reception area that reflected in the entrance space and the small window in the sitting room; and that wasn't much. Strangely enough this lack of light did not bother her, at all. Neither did the fact that the corridor was unusually long vex her. The corridor was practically useless – one of those spaces in a house where one gets from one place to another. When she reached the entrance, she paused, as if she had forgotten something, and turned around to take another look back. Images of other corridors came back to her in wartime flashbacks, just like in the movies. It was ironic how these useless spaces had become so vital during the war: Dark corridors, small bathrooms, attics above bathrooms, laundry rooms and so forth. Rooms one entered for a very specific purpose suddenly became spaces where one would live for an indeterminate length of time. She was happy with this corridor precisely because it was long and dark. It was also a bit wider than the one in the older house: There was enough leg room and enough space for a person to traverse the hall without bothering anyone sitting in it. The only thing that bothered her was the vulnerability of one of the walls – the one adjacent to the reception area – which was exposed to the large glazed opening giving to the balcony. But that was a minor problem which could be solved easily. She turned around, went back to the reception area and re-examined the wall. She decided that shelves could be built all along that wall on that side of the reception area. She could use them to display some books – her husband would love that – or plants, or china or whatever. It didn't matter as long as this addition would provide some form of added protection. Satisfied with the results, she headed back towards the kitchen.

She pushed open a door and found a generous, well-equipped space before her: Beige ceramic tiles on the floor, light olive-green ceramic tiles on the walls, some of the wall tiles even had cute little flowers decorating them. The sink was big enough, and alongside it a wide working counter space, all resin. The cupboards were made of light-coloured wood, and echoed the colour of the floor tiles. An alcove in the wall revealed where the refrigerator could be fitted, and moreover, the centre of the kitchen was vast enough to accommodate a small table that could be used for family meals. Light came in from a horizontal window on her left, just above the sink and the working area. She was a bit overwhelmed by the colourful surroundings, especially as the rest of the house was plain white, and nothing else. In front of her, to her left, was a small opening that led to a maid's room, a laundry room and a small kitchen balcony; another swinging door to her right connected the kitchen to the dining room. Right next to the door was a small horizontal opening in the wall, almost a slit that she found a bit unusual. She didn't think much of it at first. As she took a few steps towards the sink to examine the faucets more closely that slit remained in the back of her mind. She turned around again, and stood in front of it. She couldn't figure out what it was that was gnawing at her, so she lowered her head to try to look through it. She was still too high; so she crouched a little. She could clearly see the dining room. She then took a few steps backwards towards the sink, and looked again at the slit: had there been a dining table, she would be able to see the people seated at it quite clearly – what bothered her was that they could see her too. Could they? She opened the door and went to the other side; she crouched a

bit, or rather she tried as best she could to mimic the position of someone seated at an imaginary table. She had the dining room window to her back and it was obvious that anyone seated there would be set against the light, so he or she would be able to see her. But she wouldn't even be able to make out their features with such backlight. "What a stupid idea to put that opening there!" she thought to herself. How is she going to work in a kitchen knowing that people would be watching her? Even if no one was, even if she couldn't see their eyes or their appearance, the mere idea that she could be watched by someone transformed that slit into an eye, into a gaze. "Stupid architect! What was he thinking? How could he make such a decision? And besides, what on earth is that opening good for? I'll have to find someone to seal it off." That last sentence was almost out loud. Had there been another person standing with her in the room, they would be able to see her eyebrows knot close together with an angry expression overtaking her otherwise placid face. In retrospect, one could mistake this anger as misplaced. An opening can be easily sealed off with no harm done. But, that type of thinking only works if we accept what we have been taught without questioning: That walls have no memory and that's the end of it; when we seal off an opening it just disappears, with no traces left of what was revealed through it. Deep down she knew that this was not true; that each time she would look at that wall she would know that there had been an opening there; and that this opening had once been a gaze examining what she believed was her space, surveying her movement about that space. For a brief moment she thought that she would never be able to work in that kitchen again, but immediately dismissed the idea as silly and quickly headed forward, towards the kitchen balcony.

It was a small space, almost like an enclave created by the walls of the maid's room and the laundry room. The front façade was enclosed by a wall of chequered motif made of brick and open space. It worked to allow in light and air, while obstructing the vision of those looking from the outside in. "If the house was a body, that part would be the anus", she thought to herself, smiling. And who would want to expose his rear-end to an onlookers' gaze? It was a wise decision to cover that mess she thought as she quickly decided where the barbecue would go. Her husband loved barbecued meat, and insisted on having some every Sunday, much to the dismay of their neighbours, who were bothered by the smoke and the smells. Their daughter especially thought the whole process was barbaric and peasant-like. How times change! The barbecue always reminded her of her grandmother's kitchen, where everything was made of stone and solid wood. The floor was made of a simple concrete slab, which extended to the outside, towards the garden, defining a small space in front of the kitchen where much of the work could be done. Her grandmother would always prepare charcoal-grilled chicken for her every Friday afternoon when she came to stay at her place over the weekend. Those neighbours wouldn't complain of course, they were far enough and probably grilling something themselves. She remembered how her grandmother used to move in and out through the only opening in the kitchen, which was a large door that she remembers as always open: How her body was in oneness with the inside and the outside space, how everything flowed from the inside to the outside and vice versa. Things have changed indeed. Even if she wanted to unify the space with

Territories of Difference
Excerpts from an E-mail Exchange between Tony Chakar, Bilal Khbeiz and Walid Sadek
Stephen Wright

In the spring of 2003, the Italian publication *Flash Art* was looking for someone to write what the assistant editor described as an "overview'" of the important trends in contemporary art in the Arab world. When they contacted me, I suggested that this essay be accompanied by extracts of an on-going conversation between myself, Tony Chakar, Bilal Khbeiz, and Walid Sadek — three Beirut-based artists and intellectuals. This was agreed upon, but the assistant editor then sent an e-mail to the other participants in the proposed discussion panel, emphasising the need for glossy images. She received the following reply from Walid Sadek:

> You mention an "overview" essay. To be honest with you, we are really not interested in figuring in such an essay especially since we strongly believe that geography must be rethought critically and that consequently differences will emerge as significant and crucial. Keep in mind that you are dealing here with three artists whose work is largely dealing with the impossibility of producing images in the regions. We are sincerely uninterested in building an artistic career but we are rather engaged in serious debates which require different strategies for dissemination.

This is not the sort of obsequious e-mail *Flash Art* is in the habit of receiving from artists, images of whose work they have expressed interest in reproducing. It is an impeccably clear and firm refusal to play along with the mainstream art world and the values underpinning it. The following excerpt from our discussion was sent to *Flash Art* by the appointed date. It was neither published nor declined for publication; indeed it was never acknowledged in any way. It would be rash to speculate on the meaning of the silence with which it was met, but we would like to think that it is because our exchange stands as an implicit deconstruction of the whole notion of "overviewing" reality.

Stephen Wright

I want to speculate on what structural factors might account for the uncommon intellectual creativity one finds in Beirut. You three are very involved in the group of artists and theorists who, every Tuesday, gather in a café to confront your ideas in a well-prepared, though entirely non-institutional (or let's say proto-institutional) framework. On the face of things, looking at your modus operandi, it seems as if in the Middle East there are artists, but no artworld *per se* — understood as a relatively autonomous sphere, structured and governed by its own specific logic. Consequently, artists like yourselves end up implementing your art-specific skills in an extra-artistic, extra-disciplinary sphere. Inasmuch as political activism is not currently a viable option, you tend to intervene in the realm of ideas, which is in itself a relatively autonomous sphere. To say that your art-informed, art-related interventions are "art" in that framework is to wilfully suspend disbelief and make "as if". Hence the tension between documentary and fiction so prevalent in a lot of work; between authored and unauthored works. All these disciplinary border fudgings mirror the geopolitical border conflicts that are the plight of so many lives. Artists in Paris, for instance, have the inverse logic to cope with: the autonomous sphere of art spreads out to take everything in — art, non-art, anti-art. What I'd really like to know is how you see the Beirut art world — the aggregate of individual perceptions, underwritten and promoted by various institutions, media and so on — as having changed over the past five or so years, and even since the end of the civil war.

File: Public Time, Bilal Khbeiz, Fadi Abdullah, Walid Sadek HomeWorks III ي عبدالله، وليد صادق

Above: Bilal Khbeiz, Fadi Abdallah and Walid Sadek, *Public Time*. Cover page. Copies of the 15-page Arabic text, presented on a table without any title cards, during *Homeworks III, A Forum on Cultural Practices*, Beirut, 2005.

Walid Sadek

By way of approaching the challenges and assumptions of what is perceived from "without" as a lack of art institutions in Lebanon and consequently from "within" as disability, I think that we must reconsider our own *petite mythologie* surrounding art in post-war Beirut. Looking back, one must acknowledge that a number of associations did successively shoulder the responsibility of promoting alternative art practices. One could mention the crucial role played by the *Beirut Theatre* in proffering common grounds for a city long divided into east and west. Active and at times vociferous, The Beirut Theatre defended and at times funded, primarily between 1992 and 1998, many local and visiting artists, organised debates, and gave a locale to a fragmented left-wing politics. Also, the *Ayloul Festival*, 1997–2000, was an important source for funding and promoting the contemporary arts, insisting on revitalising forgotten places within the city. *Ashkal Alwan* was and still is an active association seeking debates and often inventing polemics concerning "public space". Other associations such as *Née à Beyrouth* and *Beirut Cinematic Days* still offer forums for new film productions. Although the list could be extended a little further, it is already clear that we must ask ourselves why these associations which perhaps did entertain the ambition of becoming institutions, were nevertheless unable to do so? But what is an institution? What are its effects? I would suggest that institutions act on two concomitant registers: firstly they draw the surrounding territory into their own geography. And secondly, they promote specialisation as a necessary condition for membership. Accordingly, one must ponder the politics of geography that dominated much of the 1990s and then consider the effects of a lack of, or at least deferred specialisation, on the profession and professionals of art.

Geography in Beirut carries the marks of multiple baptisms and is therefore still insubordinate. As for the reluctance of some artists to limit their work within the codes of one genre, it is but a mark of an inability to graduate above the changing demands of a locality made up of the residual matter of wars, defeats and survivals.

Bilal Khbeiz

The relation established by Arab Liberation movements with the arts
in the last fifty years demanded the total subservience of the arts to
politics. For these movements, the arts were no more than an initial
but solitary and remedial expression. Where a poem may resemble a tear,
a painting may amount to a scream and a novel may exceed expectations
and act as a warning or a reversed historiography. Within such prescriptions,
the arts were always successful in communing with their audiences.
In that context, the artist was, like Rilke, the person most capable of
expressing general and common emotions. If it seems of late that the
arts have finally escaped the edicts of politics, it is nevertheless quite
uncertain as to what this liberation amounts to. The issue here is not
that of political institutions, but rather of what to do with all these
(emancipated) artists — performers and singers included. Artists here,
like in other parts of the world, are allowed to raise objections, denounce
American foreign policies, win Nobel prizes, without ever disturbing the
structure of entertainment in which they function. Can I not ask at this
point whether there is really a world for art anywhere in this world?
Or is it only a luxury?

At any rate, a world for art is something we never constructed here.
That can be equally true of other democratic institutions although we
often raise our voices, asking for freedom of speech and democracy,
which for us are synonymous with stubbornness. I can speak of many
artists here in Beirut — as well as artists in Istanbul or Damascus —
for whom art is an escape from living. Their art, donning the façade
of constant celebration, is but the exorbitant price paid for a safe
and solitary existence. A simple question, if I may: Does the world
of art train individuals willing to build a point of view born out of
an engagement with living in the world?

Tony Chakar

Stephen, I've read what you've written many times, and each time the
thought of belonging to a "region", namely the Middle East, surprises
me — not out of an internationalist refusal to belong to a specific region,
or out of denial of belonging to a "backward" region and the desire to
identify with a more elegant appellation ("Mediterranean" for instance).
The more I thought about it the more it didn't make any sense. What
does it mean that I'm from the "Middle East"? What does it mean to a
European and what does it mean for me? In fact, the region itself doesn't
exist. We might talk about it as much as you want but it's still not there.
Or maybe it does exist inasmuch as it has to answer existential questions,
questions relating to its existence. Do you think I might be able to
understand what it means to live under Saddam Hussein's dictatorship
or to be "liberated" by the Americans? Or would I be able to understand
what it means to be living under the constant threat of being "transferred"
from Ramallah to Jordan? Or would I be able to understand what it
means to live in a megalopolis of 20 million people like Cairo? How can
we connect or find a common ground — and if you want to write about
art in the "region", what would be your theoretical ground?

Stephen Wright

As I see it, the Middle East has no immutable essence, no ontology;
you are not a Third World intellectual any more than I am a European

intellectual, and neither of us has anything to gain by grounding our arguments on such notions. Both in their own ways are ways of appealing to some epistemological privilege (victimology or supposedly disinterested universalism). It occurs to me that perhaps your uneasy acceptance of being described as a "Middle Eastern" artist stems from the fact that Orientalism always construed the Orient as an essential category, the product of a consolidated worldview; and that the only coherent response is to reject all collective labels out of hand, and to advocate a picture of incommensurably discrepant and particular experiences. What interests me, artistically, are your deep-set misgivings about "picture politics", a pitfall which the most sincerely well-intentioned artwork has a hard time avoiding. Picture politics involve the claim that one is doing politically relevant art by merely transferring political issues into images. In an era when the relationship to politics is one of the legitimating arguments for the very existence of public art, many art practices, and the institutions that support them, have all too often come to think of themselves as being at the cutting-edge of political action and have managed to lend, not the semblance of truth, but the trustworthiness of convention to that often dubious self-stylisation. As I tried to suggest, the absence of an art world has paradoxically given you room — or rather has deprived you of the room — to fall into that trap.

Tony Chakar

The Middle East leads a life of its own in political and/or ideological discourses. This life is in sharp contradiction with a lived experience that is negating the concept more and more, and yet the term as it exists does not subside. In fact, not only does it not subside, or, in other words, play a passive role, but the concept itself, as we hear about it in the news or read about it in the papers is hindering a certain awareness of difference among the people from the region. But how is discussing this issue pertinent and relevant to a discussion about art? I think it has to do with the function of art in society, or in more personal terms with why I am often so embarrassed at having to say what exactly it is that I do.

To return to what you've written, I'd say that I perfectly agree with you: art is whimsical — especially in societies such as ours that have still to deal with so many issues that people in the West take for granted. In the West, the whimsical is tolerated and even encouraged, I'd even say that there is a market for it, and artists are supposed to behave, talk, dress in a way that reveals their essentially whimsical nature. In my "region" of the world, or in the Third World in general, the situation is not that different; the difference is that what goes on in the West is the reference, and in that sense if one to "become" an artist, one must adopt not only the "styles"of Western art and, for the praised artists, the debates that come with them, but also the postures of Western artists. What this does, among other things, is to further alienate people from art, even in its most immediate, sensorial experience. The consequences of such alienation have been disastrous, and led to a refusal of modernity altogether — of a modernity that wasn't much of a modernity to begin with.

Take the usual complaints of artists and art critics here in the Arab world, for, not just now, but since the end of the nineteenthth century. They always complain about people not "understanding" them, about how they have to survive in a separate, and often hostile, environment; about how the Arab states do not take steps to "encourage" art and

different forms of art practice. Many artists took refuge in the idea that they are "too good" for their societies, and that even if they are not appreciated now, they will certainly be appreciated by future generations. Almost all of these artists were firmly convinced that the work they are producing, in spite of everything, is actively contributing to what is referred to as the *Arabic Nahda*, a mistranslation of the word "Renaissance". Nahda comes from the Arabic root-verb "N/H/D", pronounced NaHaDa, indicating the rise of some entity from its slumber — while Renaissance presupposes the death of an "old" and the rebirth of a "new". Certain artists found a way out of this dilemma by tuning into what "goes on" in the West, at the same time keeping a dose of "'locality" — a locality that easily fits in some Western discourses about art influenced by post-colonialism, feminism, the struggle for human rights, etc.

I don't feel that I, or the people I know and with whom I work, fit into any of these categories. I don't think that we even want to fit into them. I think that this is what struck you as an "absence of structure". Yet a structure does exist, and it is fully operational, but people like me decided long ago that we cannot work within it, and that if any work should be produced, and produce meaning with it, we had to look

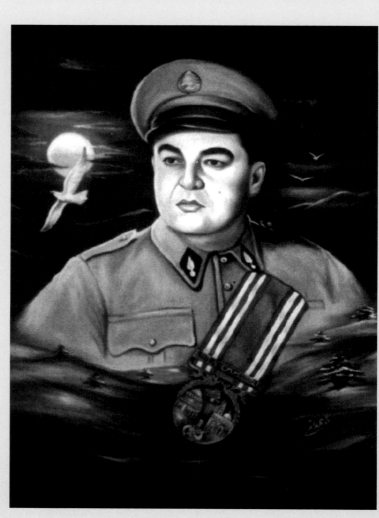

Tony Chakar, *4 Cotton Underwear for Tony*, 2002. Postcard.
Tony Chakar's father, a policeman, was one of the first victims of civil war in Lebanon. On a day off duty in the first days of the war in 1975, he left his home in East Beirut to do some shopping downtown in West Beirut. He was killed by a sniper as he crossed what would come to be known as the Green Line, separating the city in two. In his pocket, there was a shopping list with a single entry: '4 cotton underwear for Tony'. After the end of the war, all victims were attributed the status of martyrs, whatever the circumstances of their death. In 2001, Tony Chakar decided that since his father henceforth enjoyed the status of a martyr despite himself, he should also enjoy the appropriate martyrological iconography. He therefore went to see one of the official portrait painters of Hezbollah (Ahmad Abdallah), showed him a black & white identity picture of his father, and asked him to paint a portrait of his father in keeping with the iconological conventions used for depicting Shi'ite martyrs. The painter, unaccustomed to portraying Christian martyrs, decided to add several cedar trees to the picture, thereby reinforcing the pictorial paradox inasmuch as Lebanese Cedars do not grow in the Shi'ite south of the country, and are in fact emblematic of the First Republic, that is, of the republic of Christian hegemony in Lebanon.

somewhere else. We had to return to a certain "ground zero" in artistic production, and leave nothing untouched by almost obsessive scrutiny.

Only now can I explain why I insisted so much on criticising the notion of the Middle East as it exists in politico-ideological discourses, and only now can I justify my embarrassment with regard to the word "artist". For almost 200 years, we have been told that the Arab nation is one and that, if it is divided now, it is because of colonial interests and/or imperialism and/or Christian Western culture (it depends on who is doing the talking). What is latent in all these discourses, or more accurately what is considered to be "natural" is the irrefutable and immutable fact that "we Arabs" form one nation (Stephen, who? Lebanon?). Again, my aim is not to deny the existence of what is Arab, but to criticise and destabilise the notions on which the concept is founded. What preoccupies me the most is that these notions find their legitimacy in a mythologised past in urgent need of scrutiny. As I said earlier, there are differences, depending on which city or country of the region you're in, in how individuals relate to the exterinal world. My claim is that these differences are minimised in Europe in spite of the immense cultural and historical differences between the French and the Germans, to name only two. The differences in this region lie precisely in the present, and this is why they are contemptuously ignored by all the totalising political ideologies, from early pan-Arabism to today's many versions of Islamism. My question is: could art find its territory in these uncharted territories of difference? That would be, I believe, a good place to start.

Walid Sadek

I suggest that a distinction be made between charting possible "territories of difference" and interrogating the dismissal or at least avoidance of such territories. The latter direction requires a critique of the lingering and still dominant cautionary rhetoric of Pan-Arabist discourse, now overlaid by Pan-Islamist edicts. In the face of totalising discourses and edicts, art practices carry the responsibility of challenging identity-based politics. The issue is to critique identity and consequently representation as the act by which a combat of wills is played out. Obviously, this difference of mobility falls within the domain of art and does not enter the purview of political activity except as a critique. This proposal may lead us of course to consign the whole of art to the bin of history or to the spas of the retired. But I think that it would be an exorbitant mistake to expect of art practices to engage more directly with politics. Further, I find the list of denominable names such as Arab World, Pan-Arab Nation, Islamic World, Middle East, Near East, Orient, Levant, MENA, quite significant in its attempt to baptise a region. The mere repetition that defines this growing list of names is indicative, on the one hand, of a lacuna that occupies the centre of a wilful act of representation. On the other hand, I take this list to be connotative of a certain thickness, an insubordinate material presence that persists in exceeding that same act of representation. This is again an invitation to reconsider the role of institutions as actions which, necessarily, seek to fold the multiple material presence of a terrain within the baptismal moment of their own geography.

Tony Chakar

Walid's answer touches on a very important issue, which is the history of this region. As I said previously, this history needs to be scrutinised in the most severe way — and in a sense it has yet to be written. If one listens to contemporary political discourses emerging from the Arab countries, one can easily detect ideas that have become ossified to the point of suffocation (the suffocation of the listener that is — the speaker is very much contented). There is no lack of examples, but I'd rather choose one from the recent history of Lebanon to prove my point (and thus begin charting one territory of difference; the wars that took place in Lebanon in general and Beirut in particular — the object of this chart is bound to these entities). Since the end of the Lebanese wars (or rather, since the fighting ceased), Lebanese political discourse has been caught in a duality which seems hard to break. Either we completely forget about our recent past in order to "start anew" (the official slogan would be "to forgive and forget"), or we frantically search for every little detail, every insignificant story that took place during these wars in order to construct what is commonly known as a "collective memory". What both positions fail to address is that history is not merely a therapy. History, or the writing of history, becomes a project that perpetually reconstructs itself and is hence in direct opposition to a certain kind of historical writing that prevails in this region and probably everywhere in the world, that seeks to establish a fixed and transhistorical "identity"; or rather, to establish a series of essential identities, each at war with all the others. In that sense, remembering or forgetting becomes beside the point.

It is more a question of what is brought back from the past, and in what form, that produces meaning in the present. I can give this example: a new pub has opened in Monnot Street in Beirut. It borrows its name *1975*, its décor and its music from the war period: walls artificially 'damaged' by shrapnel, sand bags (or rather, plastic bags filled with foam and emulating the form of sand bags), cushions laid haphazardly on the floor, fluorescent lighting like we used to have during the fighting (except this time it comes in a trendy light blue, that manages to make people look sickly), songs from Fayruz, Ziad Rahbani, Marcel Khalifeh and so forth. Historical material comes back as empty signs, and the relationships that these signs establish among themselves can only be aesthetic ones, or relations governed by "good taste". But the question that has haunted me throughout this conversation is why is it that we cannot start talking about art — strategies, practices, or whatever — without first immersing ourselves in politics?

WALID SADEK
LOVE IS BLIND

* لا تستوي أصابع في يد. قالسبّابة إسم والنسيان إيهام في الفم.

مصطفى فروخ (١٩٠١–١٩٥٧)	Moustafa Farroukh (1901-1957)
منظر من بيروت	*View of Beirut*
١٩٣٦	1936
زيت على خشب معاكس	Oil on ply-wood
٥٢×٣٩،٥ سم	39.5 x 52 cm
موقعة ومؤرخة في الأسفل إلى اليمين	Signed and dated on lower right corner
مجموعة السيد والسيدة زياد دلول	Collection of Mr. and Mrs. Ziad Dalloul

Walid Sadek, *Love is Blind*, 2006.
Text.

* Disparate are fingers in a hand. The index is name, forgetting is a thumb in mouth.

WALID SADEK
IN HEALTH BUT MOSTLY IN SICKNESS: THE AUTOBIOGRAPHY OF MOUSTAFA FARROUKH

In the first chapter of his memoirs entitled *Tariki Ilal Fen* (*My Path to Art*),[1] begun in 1924 and published posthumously in 1986, the Lebanese painter Mustafa Farroukh[2] offers his successors a disarming formula for a starting point. If any succeeding Lebanese artist was ever to wonder, perplexed, on how to first claim a beginning, Farroukh has his answer. He writes:

And I remember once on the street stumbling upon a small box of coloured pencils — I know not what fortune brought it my way. But once they were in the grip of my hand, I hurried home, stretched out on the floor, let my thirsty spirit roam and gave reign to my imagination, expressing with those haggard pencils the rambles of my youthful self.[3]

Farroukh's beginning is as much an *initium* — a springing forth — as it is an *epiphania* — an appearance that requires of the beholder a complete surrender to the augury momentarily manifested. A miraculous beginning, which launches the boy on a course, indelibly and impersonally, set. An avocation, a calling away, necessarily coincidental for what is otherwise an unlikely calling for a young Sunni boy from Beirut.[4] When read historically within the genre of artists' biographies, Farroukh's beginning repeats the structural role of the foundational myth already established by that genre[5] and is accordingly employed to override social and historical conditions with the momentum of a prefigured destiny. Yet, in his autobiography, Farroukh does not employ the story of his miraculous beginning to turn his back on and abandon his inherited world for the other world of art. Rather, he seems to require such a beginning in order to seek another origin for himself from which he could then intervene in the world he actually lives in. With customary wit and concise perspicacity Farroukh clearly indicates the social necessity for such a miraculous beginning:

My folk were not descendants of the great Raphael, but rather commoners of these lands, never having heard of art nor of anything called painting, that which moreover is forbidden according to religious interpretation and considered as the act of an apostate or a disbeliever according to an otherwise magnanimous [Islamic] law.[6]

Born in Beirut in 1901 to a humble Muslim Sunni family, Farroukh deploys in his memoirs the three main characteristics of the archetypal artist and the one event requisite to set them in motion: a divine providence comes to ignite the young boy on a career already prefigured in his precocious talent. It sets him on the path of teachers who actually never exceed the role of temporary mentors — considering the inevitable ascension of the elected artist — leading him thus to climb the social ladder without

1 Moustafa Farroukh, *Tariki Ilal Fen* (*My Path to Art*), Institute Nawfal, Beirut, 1986.

2 Moustafa Farroukh (1901–57), a Lebanese painter and writer, graduated from the Royal College of Fine Arts in Rome in 1927. He returned to Lebanon in 1932 and led a successful career primarily as a portraitist. Next to his autobiography, his most significant writings are published in *Art and Life*, Dar Al E'lem Lil Malayeen, Beirut, 1967, and *Rihla Ila Bilad Al Majd Al Mafkoud* (*Journey to the Land of Lost Glory*) first published in 1932 by Dar Al Kashaf, Beirut and then in a second edition in 1982 by Dar Al Moufid, Beirut.

3 *Tariki Ilal Fen*, pp. 29 and 31 (English translations mine).

4 The absence of artistic vocations in Farroukh's own family and social milieu seems to have irked many in their attempts to account for the painter's talent. A case in point is a brief biography of the artist written by Dr Omar Farroukh and published in *Art and Life*, a collection of short essays by Moustafa Farroukh. In his attempt to clarify the issue, Dr Farroukh insists that the painter grew in a family of skilled craftsmen. He writes: "Moustafa's father, Mohammad, although illiterate was a coppersmith with artistic potential. A riveting storyteller he memorised tales and poems and skilfully interjected them into his speech." Also, Moustafa's older brother, "Abdel Karim was a skilful shoemaker, an artist in his trade. His capabilities were such that with a mere look at a customer's feet he could fashion an Arabic shoe that fit perfectly." The biographer then makes the necessary leap and states: "I recount all this to show that the home of Moustafa Farroukh was not devoid of genius even if lacking proper schooling." See *Art and Life*, pp. 14–15.

5 In his often-cited *Lives of the Artists*, Giorgio Vasari (1511–74) lays down a topology of artists' biographies. His chapter on the Florentine painter Giotto is exemplary as to his deployment of a miraculous beginning that will startle Italian painting. See Vasari, *Lives of the Artists* (1568), Penguin Books, Harmondsworth 1972.

6 *Tariki Ilal Fen*, p. 29.

ever shedding the aura of his pre-mundane beginning.[7] Farroukh's fortunate coincidence, stumbling on the abandoned box of coloured pencils, is his rightful claim to a personal beginning. It is the spark of a motivated gift that will not prevaricate even if never completely understood: his precocity, although supposedly visible in his early drawings, remains mysterious for he never saw, we are told, a picture before his tenth year except for those found on playing cards.[8] Also, when chided by clerics for concocting the unlawful and the illicit, namely pictures, he finds in the unique and lucid guidance of Cheikh Mustapha Al Ghalayini[9] a modicum of encouragement to set him again on his decided path:

> Cheikh Mustapha Al Ghalayini asked me: How is drawing with you today? And I answered as a guileless child would: "I quit." And when he asked me why I answered: "They said that on judgement day I would be forced to give each one of my drawings a soul or else be cast in hell." Hearing my words he laughed and said: "No matter! You draw the pictures and I will provide them with souls." and that is what we have been doing ever since: I drawing pictures and he providing souls …[10]

Page after page, Farroukh's memoirs tell of the artist's travels to the capitals of art such as Rome, Paris and Madrid. And although he often lingers when describing long sleepless nights spent practising the art of painting, it is nevertheless noticeable that the growth of his artistry is not to be assessed in his paintings — which at that stage are well within the purview of established academic skills. Rather, it is evidenced by his travels, his growing gumption and his many acquaintances among renowned European academic teachers and later among local Lebanese politicians, leaders and artists. One could simply conclude that Farroukh's path to art is primarily a tale of a traveller. That he, the artist, is the breadth and length of his peregrinations and that his drawings and paintings are at best an obvious appendix to a life lived as a practicing artist and at worst a distracting alibi from his activity as an artist persona. These last comments are not meant to belittle the artist. Rather, they wish to note that Farroukh's most important work is his autobiography. Not because it remains a rare and generous example in a genre often casually practised by artists, but rather because of a sense of completion which frames the tale from beginning to end. Simply stated, the problematic that is unearthed in Farroukh's text is that an artist's biography is a tale composed of predictable events. That is of events that never dissuade the artist nor push him to digress from the set path mythically prefigured in the auguries that punctuate his childhood. There is nothing unpredictable in Farroukh's biography. Aside from the coincidence that set him on his path early in life, nothing irrupts into the set stage of his journey. There are no sudden openings and no disruptive collapses. The life he writes is a cumulative edifice of actions foretold. His denouncement of the European avant-garde art movements is a case in point:

> The current exploitation of art is a sweeping tendency supported by powerful international elements with destructive aims and hellish wishes. And all we can do to resist is walk the path of artistic labour, withstand the pain and bear the injuries in order to lessen in the hearts of the young the nefarious effects of such distortions of art.[11]

7 In their *Legend, Myth and Magic in the Image of the Artist*, (1934), Ernst Kris and Otto Kurz develop a theory of a unitary artist biography. They write: "… Our thesis is that from the moment when the artist made his appearance in historical records, certain stereotyped notions were linked with his work and his person — preconceptions that have never entirely lost their significance and that still influence our view of what an artist is" (Yale University Press, New Haven and London, 1979, p. 4). The three stereotyped notions or primary motifs are: Auto-didacticism and the absence of a single teacher to emulate, accidental but decisive circumstances, and nature being the only model. See Chapter 2: "The Heroisation of the Artist in Biography", pp. 13–60.

8 *Tariki Ilal Fen*, p. 31.

9 Cheikh Mustapha Ghalayini (1885–1944), a man of letters, judge and pedagogue.

10 *Tariki Ilal Fen*, p. 33.

11 *Tariki Ilal Fen*, p. 180.

The inability to see new art except in terms of international conspiracy is inevitable and foundational to his desire to become a member of the brotherhood of the artist-as-civilizer. And to become a civilizer, an artist must "always already" be civilized. There can be nothing new for him to discover. His precocity is miraculous because it is already complete. What events occur during his time are not to be taken seriously. Knowledge is already acquired. What remains is its dissemination. That is why Farroukh's autobiography cannot avoid being formulaic. For no matter the artistic and social value of his artworks, they are primarily exercises in the process of learning how to channel raw abilities into a hortative plea for civilisation.

It is nevertheless crucial to note that Farroukh's memoirs are strung tight across a river of failure. For him the Arabic-Islamic past is a constant reminder of a decadent present that is moreover oblivious to mourning. In chapter 21 of his autobiography entitled "Rihla ila Bilad al Majd al Mafkoud" (or "Journey to the Land of Lost Glory"), later developed into a separate book, he lays down the basis of his cultural despondency: "The plain truth is that we live on the margins of life. We do not contribute effectually to the development of civilization, we merely exploit it."[12] Such is the tenor of his statements jotted down throughout a journey made in 1930 during which he spent a week in Seville, five days in Cordoba, two days in Madrid, one day in Toledo, four days in Barcelona and a crucial nineteen days in Grenada. His trip to Andalusia took him to what can be thought of as the backstage of his epiphany, which had him, stumble on that box of haggard coloured pencils. In Andalusia, he finally returns to see his origins. Belatedly, he describes as "wondrous monuments and poignant history"[13] a world from which he is barred but which he will unwaveringly claim as his own. For if the box of coloured pencils set him on his path, in Andalusia he beholds his true childhood, his innocence. There he discovers that he is in fact

of a higher birth. There, he meets and claims his true parents. Such is Farroukh's "Family Romance"[14] in which he is finally discovered by an ideal and exalted parent, Andalusia, and which allows him to finally turn his biological parents into foster parents. The exorbitant price to pay for such a childhood found and then forever lost in Arab Islamic antiquity becomes for the artist his Medal of Honour. Firstly, he proclaims for himself a solitude that is essential to his conception of the individual and "exiled" artist:

And I say, no matter how odd it may sound, that never when leaving the West heading home did I experience the kind of felicity and gladness usually described by returnees. Quite on the contrary, what I feel is gloom taking hold of me, not out of hatred toward my country, but because of a painful feeling at seeing it so degenerate, reactionary and unwilling to desist from repeating those harmful traditions still dear to most like a penny is to a miser ...[15]

Further,

For wherever art is, there is my home and my chosen land. And where beauty is, there is my country and my tribe. For I cannot understand homeland, love, and tribe except through the path of a fine and transcendent beauty, where there are no limits, no obstacles, no idols and no confessional colourings such as those invented by a few narrow-minded politicians.[16]

Secondly, he prepares the vocabulary for his own apotheosis[17] as he pays a visit on his way back to

12 *Tariki Ilal Fen*, p. 178.

13 *Tariki Ilal Fen*, p. 178.

14 Freud writes: "Indeed the whole effort at replacing the real father by a superior one is only an expression of the child's longing for the happy, vanished days when his father seemed to him the noblest and strongest of men and his mother the dearest and loveliest of women ... and his fantasy is no more than the expression of a regret that those happy days have gone." Freud, Sigmund, "Family Romance", in the *Standard edition of the complete psychological works of Sigmund Freud*, vol. IX, p. 241.

15 *Tariki Ilal Fen*, p. 190.

16 *Tariki Ilal Fen*, p. 190.

17 The term "apotheosis" is used here to indicate an element of exaggeration in Farroukh's autobiography. For upon his return to Lebanon and as is evidenced in his collected essays and speeches published under the title Art and Life, Farroukh did

Lebanon to his Roman teacher: "I sought in Rome my teacher and found him as always diligently working in his studio over which door was written Pax et sacrum. Yes it is, by God, peace and sacrality."[18] In reading Farroukh's memoirs, one finds yet another version of the same tale so often told by Arab intellectuals, teachers and pedagogues of the late nineteenth and early twentieth centuries. His path to art seems unable but to mimic some of the claims made by both Islamists and Modernists or what Waddah Sharara prefers to call Al 'Assriyyeen.[19] From the latter Farroukh reiterates a call for an accelerated merger with the developed West, a merger about which we have little choice, while he mimics the former in their summoning of past Arab Islamic greatness without actually endorsing their belief in an upcoming awakening that would found a historical independence from the West. | And although seemingly eclectic in his position, he hoped to find a resolution in education, or erudition to be more precise. That is what occupied him during endless nights upon his return from his journey to Andalusia. Studiously noting his thoughts or what he calls his Ta'thirat or influences, he often refused invitations to join friends choosing his duty, so he tells us, "to disseminate what I saw of Arab glory in Andalusia for us to stand as a lesson and example".[20] This hope to educate a whole people is also what animated the preaching of both Arab Modernists and Islamists. In the words of Waddah Sharara:

> All parties agreed on diagnosing the form of an answer even though they disagreed on its content. For they all developed a response based

on Al Muthaqafa.[21] That is why they aimed to bypass all present discord and build a unitary cultural edifice tying together in one coherent whole a temporal reference (memory and identity), an institutional framework and common behavioural values. And this call to unify the values according to which a common behaviour is crystallised, springs from the self, from the mind, from will power, from ideas and beliefs or from culture understood here in its literary sense.[22]

Farroukh's memoirs could be placed side by side with other innumerable memoirs, tracts and exhortatory essays each proclaiming in slightly different ways that one and the same call for Arabs to awaken. Yet what distinguishes Farroukh's text is his claim to a providence that set him early on his path. In his autobiography, he is chosen, elected, to live a life that is foretold. Like others of his generation, he sought to know the cause of his culture's ailments, but unlike the rest he visited his future and saw that it was already behind him. In Andalusia he completed his journey and could only proceed with a life lived in deep ambivalence.[23] Graced with a divine sign he was also set inevitably apart: a man singled from a crowd, an artist rescued from his culture and delivered to watch it as a rubbled landscape. But unlike that proverbial Angel of History, our Farroukh had neither wings nor was he so privileged as to stand in the current of progress and be lifted, even if unwillingly, by its storm. In other words, he was neither equipped nor willing to swim the tides of an ambitious Modernism

not surrender to the melancholia that colours the final chapter of his autobiography. Rather, he turned his cultural alienation into a tireless and often univocal exhortation to his fellow Arabs to awaken.

18 Tariki Ilal Fen, p. 191.

19 The term Al Assriyyeen connotes contemporaneity more than modernity. See Sharara, Waddah, "Europa! Europa! Fi Ba'ad Woujouh Al Mas'ala Al Gharbiah" ("Europa!Europa! Re: Some facets of the Western Issue" (1979)), in Al Wahid Nafsouhou, Dar Al Jadid, Beirut, 1993, pp. 247–315.

20 Tariki Ilal Fen, p. 178.

21 It is important to note that the concept of Al Muthaqafa or acculturation for Sharara indicates not an adaptation or a conditioning of Arab culture to the values of the West but more precisely the problematic of developing and crystallizing a new (or old) Arab culture while under the burden of the Western issue.

22 Tariki Ilal Fen, p. 310.

23 It must be noted that in the last years of his life, suffering from leukemia, Farroukh seems to have finally shed the weight of his life-long role of civilizer. Painting under the pressure of a mortal illness he even seems unconcerned with the greatness of the Arabo-Islamic Andalusian past. In works from the mid and late 1950s such as From my Window and Self-Portrait another story is pictured and still waits to be written.

and become involved in the unmaking of academic art. Rather, he tries to make do, standing astride an ailing present with one foot on the axioms of a conservative and academic European art and the other foot on the remnants of an ancient Arab-Islamic civilization. Wingless, he attempts to stand tall. Look at him in that picture taken in 1930 leaning against one of the pillars in the courtyard of Alhambra palace in Grenada: A profoundly poignant emblem of a putative health. There he stands with all the signs of worldliness: The Panama straw hat, the pocket-handkerchief, the three-piece suit and the four-in-hand tie. Yet he is not exactly standing, not even leaning. Rather he drops against that pillar having extended his lean as if surprised that the pillar was a little too far. He tries to appear as if "of the place", a regular fixture, yet does not quite occupy his own space. He is a visitor. Not the returning prodigal son he wished he could be, but as recent an addition and as temporary as those potted cypresses. Posed to one side, he does not seem to expect a storm of progress to blow through the arched entrance just behind him. He is there for eternity, having returned to a womb that begets no more. And in this dry womb he calls on the photographic camera to perform the unlikely: Make him whole.

ZIAD ABILLAMA
POURQUOI N'ARRÊTES-TU PAS DE MOURIR?

Ziad Abillama, *Pourquoi n'Arrêtes-tu pas de Mourir?*, 2005.
Video stills.

Out of Beirut 73

RABIH MROUÉ
MAKE ME STOP SMOKING

I have been collecting worthless material for
almost ten years now, taking good care arranging it,
documenting it, indexing it, and preserving it from
any possible damage. This material is made up of
cut-outs from local newspapers, photographs,
interviews, news stories, excerpts from television
programmes, objects and other things. Today
I possess what resembles an archive, or let's say
I possess a real archive that relates only to me: a kind
of added memory that occupies different corners of
my domestic space, despite the fact that I do not
need it. It is an invented memory that is exhausting
me, and from which I cannot liberate myself.

For this reason, I will uncover some parts of my
archive, hoping that, by making it public, I can rid
myself of its weight. This is my attempt to destroy
a memory that doesn't know how to erase itself.

JOANA HADJITHOMAS
KHALIL JOREIGE
WONDER BEIRUT

Opposite and on following pages:
Joana Hadjithomas and Khalil Joreige, *Wonder Beirut:
The Story of a Pyromaniac Photographer*, 1999–2006.
Postcards.

We have been working since 1997 on a project entitled *Wonder Beirut*. Based on the work of a Lebanese photographer named Abdallah Farah whom we met at the beginning of the 1990s, the project, which includes many parts, deals with the Lebanese war, or rather wars. The project is an interrogation of history and our difficulty in writing it.

In 1968, Abdallah Farah published a series of postcards of Beirut. The absurdity of the Lebanese situation is underlined by the fact that these postcards are still on sale today in Beirut bookshops, although the monuments and sites they represent have mostly been destroyed.

At the beginning of autumn 1975, Abdallah began damaging the negatives of his postcards, burning them little by little, as if he wanted them to correspond to his contemporary situation. He imitated the destructions of the buildings he saw gradually disappearing because of bombings and street battles. His process was, at first, highly organised and documented, with the trajectory of shellings and corresponding defacing of his images relating to the events of the day. We called this first stage "the historic process".

Later, Abdallah began inflicting, accidentally or deliberately, additional destructions to those same buildings. We call this second phase the "plastic process". We decided to have these images published as a new set of eighteen postcards of war.

The second part of *Wonder Beirut* is made up of the "invisible" work of Abdallah Farah who, although still taking photos of his daily life, no longer develops them. It is enough to take them. The reels pile up. He notes, however, every single photo he takes in a book, describing each one in great detail. Hence his images are to be read rather than to be seen. This part is titled "Latent images". The work reflects our concerns. How can one produce images, reflect about their economy and their potency, considering the instability of our context; a feudal, confessional society where personal status is hard to achieve; where one can hardly find one's own rhythm; where we question how history is written.

We are attempting to find new ways to create images through evocation, absence, latency. Latency is a state which haunts all of our work. Traditionally, latency is defined as the state of what exists in a non-apparent manner, but which can manifest itself at a given moment. The latent image is the invisible, yet-to-be developed image on an exposed surface.

To this should be added the idea of "the dormant", of slumber, of slumbering, of something that can be awakened. To us, latency is beyond evidence. It is the reminiscence of an image, of knowledge but which can barely be grasped. How can one produce images, export them, move them around, while avoiding cut-and-dried definitions? As image producers, we try to avoid being made use of, or taken over by, propaganda within our country or our region, or reduced to a simplifying, often "orientalist", vision. Our work takes into account this possible risk, this breach.

Aware of this situation, we resort to the idea of the anecdotal. Etymologically, the anecdotal appears as something unrevealed, something kept secret, at odds with a certain concept of history.

In our opinion, the anectodal is not necessarily metaphoric, but rather symptomatic. It is not small history trying to reflect history at large, but a research around sensations, and the re-appropriation of events, like elements of space-time that record a specific, significant moment.

The symptomatic is therefore the possibility of an image, the manifestation of something made visible. A symptomatic image is intimately linked to its context, to a situation and to a history. It is a proposal, an experience. By going back to a personal fact, to a given event, or to "something secret", we refuse the spectacular aspect and the general sociological subject. The symptomatic image is the product of a situation that cannot be reduced to an allegory or a symbol.

The anecdotal is the possibility of appropriating our history. If we consider official history as written by the winners, there is another unofficial and subversive space governed by the anecdotal, "the thing kept secret", which perforates that official frame. Latency is about affirming a presence. The anecdotal is the story and the development of that presence.

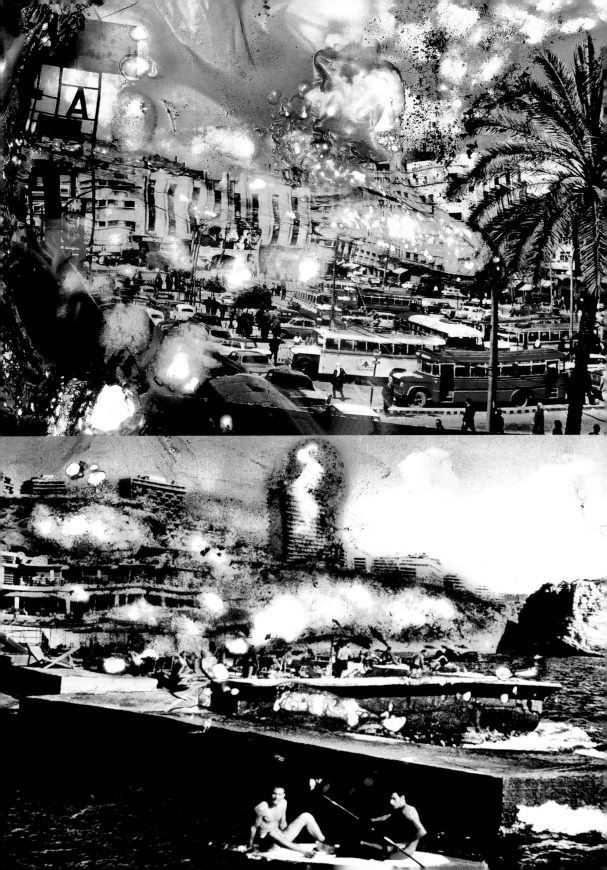

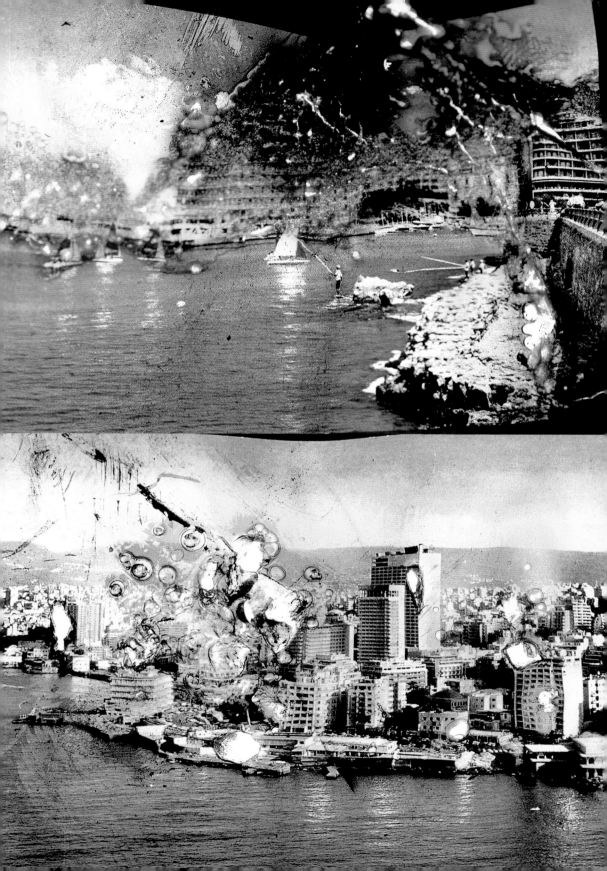

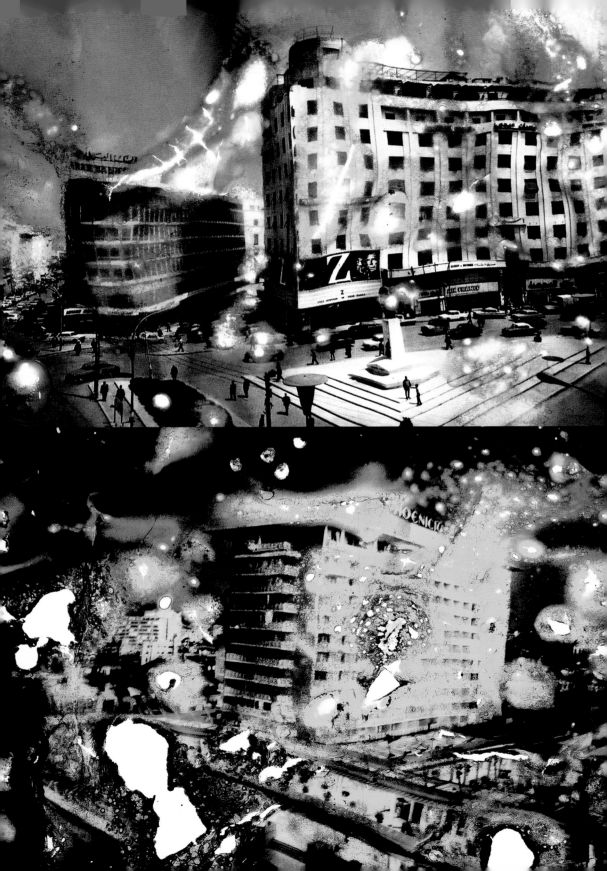

Contemporary Art Practices
In Post-war Lebanon: An Introduction
Kaelen Wilson-Goldie

1 Lamia Joreige, "Here and Perhaps Elsewhere", *Home Works II: A Forum on Cultural Practices*, Ashkal Alwan, Beirut, 2005, p. 177.

2 These are the figures that are generally agreed upon, although solid statistics are famously hard to come by in Lebanon. The estimates of how many Palestinian refugees were killed in the 1982 massacres at the Sabra and Shatila camps outside Beirut, for example, range from 800 to 3,000.

"There are many stories, but I can't tell you here."
"You're scared of them being recorded?"
"No, I'm not scared of them being recorded. But there's no reason to record them. Because they may be true and they may not, you see? Because they won't give you the answer you're looking for." — Lamia Joreige[1]

Stories lay at the heart of Lamia Joreige's *Here and Perhaps Elsewhere* (2003), a 54-minute video delving into the disappearances that occurred during Lebanon's fifteen-year civil war. Joreige plots these stories, almost literally, like points on a map of Beirut. Armed with a set of archival newspaper photographs depicting the checkpoints that once punctuated the green line — a wide no-man's-land separating the city into eastern and western sectors — Joreige sets out with a digital video camera to find and film the present-day location in each picture. As she moves from one site to another, she interviews residents in surrounding neighbourhoods, asking them for their stories. Do they know anyone who went missing from here? Do they remember the checkpoints, the kidnappings, or the killings? Do they have any idea what happened to those who disappeared?

The film splices Joreige's static checkpoint photographs — all black-and-white images with a vintage grain — into dynamic sequences of current video footage that are sharp, colourful, and roving. The juxtaposition of still and moving images not only paces the work visually but also creates a temporal disjuncture between past and present.

That disjuncture doubles as Joreige's subjects speak. They answer her questions with stories that are both visceral and vague, on and off the point. They slip between fact and fiction, between what seems to be a straightforward recollection of past events and what is clearly an interpretation of memories performed in the present. As the title of the film suggests, these stories are here and elsewhere at once. As one man tells her simply, "they may be true and they may not. You see?"

During Lebanon's civil war, from 1975 to 1990, the many thresholds between East and West Beirut became wrecked urban wastelands. Particularly in the early stages of fighting in 1975 and 1976, various militias erected roadblocks and engaged in tit-for-tat abductions along the green line. As cars approached each crossing, passengers stopped to show their identity cards, which, in addition to the usual information such as names and addresses, indicate the religious sects to which the holders belong.

Depending on the nature and intensity of skirmishes elsewhere in the city, passengers of a particular religion were sometimes killed on the spot or kidnapped to be used later as bargaining chips in prisoner swaps between fighting factions. Kidnappings took place elsewhere throughout the war but were particularly brutal at the checkpoints along the green line, where people were literally picked off to meet quotas of numbers dead or disappeared on different sides. Rough estimates suggest that about 18,000 people went missing during a conflict that claimed 150,000 lives, wounded 200,000, displaced 800,000, and caused a third of Lebanon's population to flee the country.[2]

The civil war came to a close in 1990 and, in the intervening fifteen years, very little has been done outside the efforts of non-governmental organizations to determine the fate of those who disappeared, whether

they are alive or dead, where they are being held if they are alive, or who is to be held responsible if they are dead. In six brief articles, Lebanese law delineates the criteria under which a person may be deemed missing, outlines how a judicial declaration of death may be made, and stipulates inheritance procedures, stating that those who reappear within five years may reclaim their estates from their heirs. There is no official list of missing persons and no ministry or government office is charged with handling these cases.

During this same time period, however, the physical city of Beirut has been dramatically reconstructed, particularly in the downtown area where many of the roadblocks once stood. Buildings have been torn down, plots of land have been re-zoned, and streets and traffic patterns have been redrawn, all radically altering the layout of Beirut's spatial environment.

At each checkpoint Joreige endeavours to find in the film, there is a palpable sense of disorientation. She uses the set of archival images to jog the memories of area residents, but time and time again, the interview subjects in *Here and Perhaps Elsewhere* look down at the checkpoint photographs and up at the surrounding city with expressions of confusion. To their frustration (or delight, in the case of a group of kids too young to remember anything of the war but entirely willing to try out a new game), they cannot, or perhaps will not, pinpoint the exact location. There is a repeated failure to match one view with the other, as if these images of past and present refuse to conform to a singular notion of place, let alone a coherent, collectively understood historical narrative linking one with the other.

Binding the film together are the longer sequences of people speaking on screen. Through the act of producing narratives, her subjects attempt to rehabilitate these images of the past into the present. But again Joreige encounters a kind of rhythmic refusal. One subject takes her photographs as a floodgate for polemics — he uses them as an opportunity to hurl invectives at those he still perceives to be his political enemies. Another blanks the images completely. He has nothing to say. He remembers no such thing. Others make telling narrative substitutions. Kidnappings? No, but let me tell you about my son who was killed. Some of Joreige's subjects clearly distrust her, sensing that she is not from the neighbourhood, that she is an outsider. They turn her questions back on her or try to use them for their own gain. Who wants to know and why? Will they be on tele-vision if they talk? Some of the stories they tell her are tragic while others seem suspect and Joreige does little to distinguish between them. In some cases, her subjects seem to be boasting to her, as if to be in possession of secret knowledge is to gain some measure of authority in the eyes of the film-maker and the audience that will presumably see her film.

Just as *Here and Perhaps Elsewhere* exposes rifts between past and present and between truth and fiction, the film itself shifts between elements of documentary and artistic practice. Joreige proceeds methodically from one site to the next. She repeats the same arsenal of questions like an ethnographer conducting field research. Yet *Here and Perhaps Elsewhere* is loosely and atmospherically composed. The entire documentary genre has long been contested terrain, and Joreige forces viewers to consider what exactly it means to produce a document on film or video. Joreige draws upon certain conventions of traditional documentary film-making but diverges from them as well. She actively intervenes with her subjects. She uses no voice-over narration. She

offers no statistics, no hard or fast evidence to support the history of the civil war. The film does not offer a definitive study on the subject of kidnapping or the disappeared.

What becomes clear toward the end of *Here and Perhaps Elsewhere* is that Joreige is looking for something, for one story among many. Eventually she interviews an elderly couple who relate back to her the story of her own uncle's capture. This would seem to pose a logical resolution for the film, an endpoint for its narrative arc. Yet even here, the story is unsettling in its brevity and lack of specificity. Are they simply telling her what she wants to hear, patching information together from her questions? It is difficult to know, to be sure, that the tale they tell her about her uncle is true. For the artist's sake, you want to believe it. But at the same time you have to admit, as the man says above, such stories won't give you the answer you're looking for.

Joreige's film is in many respects emblematic of contemporary art practices as they have been developing in Beirut throughout the post-war period. Her work is neither cinema nor reportage. Rather it is a video piece, an artwork, with an aesthetic and at times almost painterly skin grafted onto a conceptual spine. Like a number of her contemporaries living and working in Beirut now, Joreige uses documentary practices, eyewitness testimonies, and archival images to produce art that probes the history and legacy of Lebanon's civil war. As an artist, she works by attempting to move freely throughout the city, collecting the visual and material traces the war has left behind, and subjecting those traces to critical investigation. What do they mean? What do they refer back to? What do they represent and how do they function now?

Here and Perhaps Elsewhere poses the following questions: How was the civil war in Lebanon experienced by those who lived through it? Has the conflict been truly resolved? Have its causes and consequences been sufficiently or even adequately addressed? In giving aesthetic form to these questions, Joreige and her colleagues have staked a claim for critical positions in contemporary art that carry the potential to not only reflect but also challenge and alter the political and social realities that inform identity construction and daily life.

In the context of Beirut specifically, artists such as Joreige have made a plausible case for the presence of an avant-garde that is capable of disrupting Lebanon's mainstream artistic traditions by challenging the dominance of commercial galleries and other institutions that glom onto culture as commerce, kitsch, and escapist entertainment. In doing so, they are recalibrating the role contemporary art plays in Beirut by dismantling its standing as a bourgeois bubble set safely apart from (and above) political concerns. They are also retooling critical art practice into a force that can engage, inform, and change the contents of public discourse and the contours of public space.

More broadly, and beneath the trauma of the civil war itself, their work touches on the failures of nationalism, the fading relevance of leftist political movements that pushed for social justice and secular modernism in the developed and developing world, and the polarisation between the West and the Arab world that has become dangerously pronounced in the post 9/11 era.

Over the past fifteen years, Lebanon has witnessed a surge of contemporary art practices in video, installation, performance art, and urban intervention. A generation of artists — most of them born in the

late 1960s and early 1970s, most of them living and working in Beirut now — has taken advantage of the precarious peace and relative continuity operative in the post-war period to develop an impressive set of aesthetic practices bolstered by a substantial body of critical discourse.

The work of these artists — including Joreige, Walid Raad and The Atlas Group, Rabih Mroué and Lina Saneh, Joana Hadjithomas and Khalil Joreige, Akram Zaatari, Tony Chakar, Ziad Abillama, Marwan Rechmaoui, Alexandre Medawar, the Heartland collective, and more — has been produced and presented within an alternative and informal infrastructure for cultural production that has, for the most part, grown up around such institutions as the Ayloul Festival (held every September in Beirut from 1997 to 2001), Ashkal Alwan (the Lebanese Association for Plastic Arts), and more recently through initiatives poised as further alternatives to those associations (such as AIW:A, the Artists International Workshop in Aley, and the joint projects of video artists Mahmoud Hojeij and Ziad Antar in Saida).

In contrast to both previous and parallel art movements in Lebanon, these artists are less concerned with work that positions a purely aesthetic object in a local commercial market and more concerned with work that is experimental, research-based, and critically engaged with sociopolitical issues related to identity, representation, the writing of history, the production of knowledge, and the exercise of power.

Because these works have been staged for the most part as site-specific installations, one-off performances, and urban interventions outside Beirut's gallery system (comprising such venues as Galerie Épreuve d'Artiste, Galerie Janine Rubeiz, Aida Cherfan Fine Art, Galerie Alwane, and the Agial Art Gallery, where exhibitions of primarily paintings and sculptures are scheduled, announced, mounted, attended, and reviewed with predictable regularity), they are necessarily ephemeral. They have been documented in photographs, videos, and texts, but they have not mobilised local audiences in the same numbers as other, more mainstream forms of cultural production (such as film, popular theatre, and to a lesser extent literature).

Nonetheless, starting in the late 1990s, many of these artists have come to be feted by the international art world to the extent that their work is better known abroad than at home, where local audiences remain largely indifferent, and at times oblivious to or even disdainful of their output. That the work these artists produce has a stronger presence internationally than locally, despite the fact that it is deeply entrenched in issues that are arguably more relevant and specific to Lebanon than anywhere else, is nothing short of paradoxical.

The contemporary art practices under discussion here are inextricably bound to Lebanon's public discourse about the civil war, the reconstruction era, and reconciliation in relation to ongoing debates about national identity and regional politics. They have developed in tandem with rigorous debates over collective memory and amnesia, over how the history and experience of the civil war might be used, remembered, represented, memorialised, or forgotten.

Public discourse about the civil war takes shape in the speeches of politicians and religious leaders. It is mediated to a certain extent through the press — in newspaper editorials, radio programming, and television talk shows that cover political life in Lebanon with a relatively free reign, an occasional recourse to doublespeak, and a surplus of sarcasm. It has

also developed through the less formal talk that takes place in religious and political gatherings, among friends and families and closed communities, through hearsay and anecdotal regurgitation, and perhaps most pervasively through rumour.[3]

This recourse to rumour is most likely a holdover from the civil war years. According to journalist and academic Samir Kassir, who published a historical overview of the civil war, *La Guerre du Liban: De la Dissension Nationale au Conflit Regional* (*The War in Lebanon: From National Dissension to Regional Conflict*), in 1994, and who was killed in a targeted car bombing in June 2005:

> Rumours ... spread easily in times of war because of a lack of solid information, and because people who might not usually meet or talk find themselves condemned to communicate with each other in the same shelter. You also have the effect of confessional polarisation. In times of conflict, members of the same religious community tend to stress what is common between them; this may include myths, ancestral imagery, a common view of history, etc. They also may share common memories of hatreds and past sufferings. One pattern that it is important to isolate is that rumours which transmit fear develop after the fear has already occurred; in turn they are used, consciously or not, to enforce solidarity within the community. Rumours reconstitute reality and are a consolation, a justification, and a legitimisation of the surrounding environment and of the behaviour of the group.[4]

The subject of the civil war recycles itself through all these channels of communication. Sometimes it is foregrounded as an actual topic, such as marking the anniversary of the civil war's start or debating the general amnesty law for those involved in the fighting. More often it looms in the background of other issues, such as discussions over the implementation of the Taif Accord, which brokered an end to hostilities in 1989, or UN Security Council Resolution 1559, calling for the withdrawal of Syrian forces from Lebanon and the disarming of groups such as Hezbollah. It also, if only superficially, figures in debates about electoral laws, the status of Palestinian refugee camps in Lebanon, the precarious balance of political sectarianism, and relations between Lebanon and its regional neighbours, principally Syria.

Contemporary art practices have also unfolded at a time when discussions about public space in Lebanon, particularly public space as it is conceived of and provided for by Solidere (the private real-estate company founded by Lebanon's former prime minister Rafik Hariri and charged with rebuilding downtown Beirut), have reached fever pitch and then cooled. Artists as well as architects and urban planners have weighed in heavily on those debates. Why? As Rosalyn Deutsche suggests generally in *Evictions: Art and Spatial Politics*: "How we define public space is intimately connected with ideas about what it means to be human, the nature of society, and the kind of political community we want."[5] As Peter Rowe and Hashim Sarkis argue more specifically:

> Because today it is so difficult to address socio-political issues directly, urban space and its remaking tend to define much of the contemporary dialogue various people in Beirut have about themselves and their world. Put more simply, urban space — including its production, transformation, use, and symbolic deployment — matters a great deal.[6]

3 See Walid Sadek, "A Matter of Words", *Parachute: Beyrouth/Beirut*, fall 2002, pp. 34–47.
4 Michael Young, "Writing a History of the Lebanese War: An Interview with Samir Kassir", *The Beirut Review*, fall 1994, p. 132.

Energetic debates about public space in Beirut peaked in the mid 1990s, as the reconstruction effort that initially seemed open and receptive to input from the general public began to proceed in line with far more private interests. Not much of a fight followed, and since then, those debates have quickly dwindled to a low-pitched whine. There is a striking parallel between the resigned disappointment over how the civil war in Lebanon was rather arbitrarily ended and the resigned disappointment over how issues of public space in Beirut were resolved by profit-seeking market forces.

Still, because open, fluid, cosmopolitan, and communal spaces were precisely those that were so thoroughly devastated during the civil war, the restoration of those spaces, and how they are made and used in Beirut, has become an intimate gauge by which the city's residents may assess how well they have recovered from the experience of the civil war. The rehabilitation of public space is a measure of how far they have distanced themselves mentally and physically from the conflict, how much further they must go in fending off the war's return, and how much room they have left to negotiate for real political change.

The viability of a public sphere is crucial to the ways in which the more critical of Beirut's artists live, work, and impress their art on a receptive audience. Public spaces — whether taken to mean public parks, civic plazas, seaside promenades, exhibition venues, or the street — determine where and how artists intervene with their work. The shifting, contradictory nuances of those spaces — the social, cultural, political, and ideological systems inscribed on them — in turn inform and affect the content of that work. The relationship is reciprocal. "Art cannot assume the existence of a public but must help to produce one," writes Deutsche.[7]

The works that critical contemporary artists are producing in post-war Lebanon, whether they catch the attention of a wide audience or not, are actually affecting the way people speak, move, construct their identities, and conduct their daily lives in Beirut by formulating a visual language that rings true to those experiences, adequately represents them, and at the same time calls attention to the limitations imposed on them.

The stakes are high for that process of defining the actual conditions of public experience in Lebanon. It is there that the legacy of the civil war, the vitality of the city, the stability of the state, the sustainability of truce and/or peace, and the possibility for political progress will be worked out. The traumatising effects of fifteen years of fighting may be overplayed and used as an excuse, but at the same time they cannot be shrugged off lightly. The roadblocks may be for the most part gone from Beirut but the mental and physical damage that surrounded them remains. The fears they provoked — along with the routines and behavioural patterns they gave rise to in order for citizens to circumvent them, to say nothing of the root causes that ushered them into existence in the first place — require longer and more complex efforts to dismantle.

If artists in Lebanon have a role to play in shaping public experience discursively and spatially, then their task carries an added sense of urgency due to the country's recent experience with fratricidal, internecine violence.

That is not to say that the occurrence of civil war renders Lebanon unique. The country is undeniably complex and some of the forms of warfare it witnessed were unprecedented, but it is not necessarily the first of its kind. Slavoj Zizek suggests that all national cultures and

5 Rosalyn Deutsche, *Evictions: Art and Spatial Politics*, MIT Press, Cambridge and London, 1996, p. 267.
6 Peter Rowe and Hashim Sarkis, eds., *Projecting Beirut: Episodes in the Construction and Reconstruction of a Modern City*, Prestel-Verlag, Munich, London, and New York, 1998, p. 10.
7 Deutsche, p. 59.

8 Saree Makdisi, "Laying Claim to Beirut: Urban Narrative and Spatial Identity in the Age of Solidere", *Critical Inquiry*, spring 1997, p. 664.

9 Lawrence Chua, "Virtual Beirut", *Transition*, issue 83, 2000, p. 36.

societies stem from some moment of extreme trauma, political crisis, or social conflict. This is as true of Lebanon as it is of any number of other countries beyond Zizek's primary study of the Balkans. But if all countries suffer some traumatic rupture of the real onto the smooth surface of the symbolic order, if all cultures assimilate a harsh brush with unconscionable violence by retroactively recasting their national identities and historical narratives to placate and protect particular groups, then Lebanon's experience has been more frequent and episodic than most.

The subject of the civil war has become so ubiquitous in Lebanon that it risks becoming one overarching trauma which effectively masks over or represses many others, all of which are condemned to the restrictions of representation. In addition to the civil war's economic machine, which ushered in a previously unknown post-war nouveau riche with real political clout, the arrival of advanced capitalism through globalisation and audacious privatisation measures has dramatically altered Lebanon's class structure, particularly over the past five to ten years. A perpetually stunted democratic system with, for example, an inadequately independent judiciary, unstable electoral laws, and ever more rubber-stamped elections leaves ordinary citizens feeling under threat not from outright violence but rather from lack of rights, due process, and meaningful political protection.

The combined, intertwined legacies of the French mandate period, an independence era marked by the creation of a welfare state and the constant meddling of foreign powers and Arab nationalism have yielded each their own elites, many of which now find their sense of self-entitlement pinched, and their once impressive institutions and infrastructures neglected and threadbare. Previously prominent political, social, economic, and cultural groups have been sidelined in the post-war era.

Resistance movements against Israel by and on behalf of the Palestinians, political mobilisation in South Lebanon, and the rise of political Islam as a resistance movement, a political safety net, and a social support system have given the economic equation between the haves and have-nots a decidedly complex political and religious cast. They have also completely trumped the state in meeting the needs of their constituents.

All these factors render Lebanon again not unique but certainly a compelling crucible. The untangling of Lebanon's many issues will likely prove both indicative and illustrative for other places and other situations in the near future.

Finally, Lebanon's perpetual underlying identity crisis is intrinsically tied as much to internal political combustion as it is to factors determined by the country's fixed geopolitical location. Relationships with and orientations toward the West, the Mediterranean region, Europe, the Arab states, and the Islamic world shift and change constantly. The current tenor of the US administration's war on terror puts Lebanon in the uneasy position of — once again — being used as a pawn in the context of deals being brokered on Iraq, Syria, and Israel.

The protracted nature of the Palestinian–Israeli conflict ensures that Lebanon's political stability, security, and economic viability will be inextricably tethered to a regional peace plan or its failure. Increased pressure on the Syrian regime, the end of its physical occupation of Lebanon in 2005 notwithstanding, reflects directly on Lebanon, informing

not only who holds political power in the country but also how Lebanon's financial lifeline via trade routes to the rest of the region function.

All these external factors seep into and subvert Lebanon's internal issues. How these issues are expressed, verbally and visually, from above and from below, largely determines the form and content of public discourse and public space. Speaking generally of Beirut in the age of Solidere and particularly of the fate of Martyrs' Square, the city's spatial and symbolic heart, literary critic Saree Makdisi remarks:

> Blank or not, the city centre is a surface that will be inscribed in the coming years in ways that will help to determine the unfolding narrative of Lebanon's national identity, which is now ever more open to question. For it is in this highly contested space that various competing visions of that identity, as well as of Lebanon's relationship to the region and to the rest of the Arab world, will be fought out. The battles this time will take the form of narratives written in space and time on the presently cleared-out blankness of the center of Beirut; indeed, they will determine the extent to which this space can be regarded as blankness or, instead, as a haunted space: a place of memories, ghosts.[8]

Representations of Beirut tend to exist in three fixed temporal registers — past, present, and future. "In Beirut, nostalgia and amnesia had come to live on the same street," writes novelist Lawrence Chua. "The city was a polyglot metropolis, and the present was only a convenient place from which to look at images of past and future."[9] What is significant about the works contemporary artists are producing in Lebanon now are the ways in which they treat the material traces of the war as symptoms, as scraps of visual information that slide around without fixed meaning, constantly renegotiated, readjusted, and assimilated into larger networks of signs and symbols. Stencilled militia insignias, pictures of dead leaders both national and regional, election season campaign flyers, political posters, generic, globalised advertising campaigns and event flyers are some of the imagery that contribute to the thickness of Beirut's visual culture juxtaposed with the still visible traces of the civil war and a skyline pierced by construction cranes.

Despite the fact that their work often requires some knowledge of Lebanon to be adequately read, there is something to be said for the kindred concerns at play between the contemporary artists in Beirut and their colleagues elsewhere. There are clear connections on the level of practice to work being produced in other regions in the Arab world as well as in the West, and particularly to work that is based on the internal workings or archives, collectivity and/or anonymity, the combination of documentary practices and video, and the projection of still and moving images — work that holds in balance an eruption of the real, or the complete foreclosure of meaning.

The desire to delve into the trauma of the civil war in Lebanon, to dig into its causes and consequences, is certainly particular to and arguably inseparable from conditions existing in Lebanon alone. But the fact that other artists in other locations are simultaneously engaged in similar practices indicates that something more universal is going on. And that leaves open the remote possibility that the root cause of the trauma buried in these artworks from Lebanon may not actually be the civil war at all.

Onto the Streets:
The Heartland Collective's
Interventionist Perspective
Kaelen Wilson-Goldie

During Beirut's municipal election season in May 2004, political candidates papered their campaign posters all over the city in the usual fashion. Photographs of various faces, scarcely distinguishable from passport pictures, multiplied at street level on stone walls, street signs, construction scaffolding, abandoned storefronts, and concrete building façades. The images accrued in multiple layers day after day in the run-up to voting.

Into the mix, an anonymous group of artists known as Heartland threw its own fictional candidate. A stencil of a man's face in black ink printed on white paper appeared among the crowd of other, more colourful flyers. The image looked as if it has been torn or scratched, defaced or partially peeled away. The man's face was round, smiling, titled down and to the right, but otherwise unrecognisable. He could have been anyone. A nondescript email address, **today@thisiscyberia. net**, was scrawled below the stencil.

Heartland's "fictional" poster campaign, an intervention called *Al-Murashah* (*The Candidate*) circulated throughout Beirut for one month. It followed the logic of similar yet "factual" poster campaigns in that Heartland's image always appeared next to, below, or among those of the other candidates. But because it jumped in proximity from one candidate to the next, it spread further, through different neighbourhoods with different constituencies, political affiliations, and sectarian allegiances.

The group documented its intervention in photographs, which were later shown in an exhibition of Heartland's work in the Laboratory, an art space reserved for shows that are, by Beiruti standards, experimental and non-commercial, housed within Espace SD, a contemporary art gallery in the rapidly gentrifying neighbourhood of Gemmayzeh. The exhibition announcement featured one such photograph, a thick collage of campaign posters overlaid with a hand-drawn map of Beirut, the group's email addressed painted onto a shuttered storefront, and the decorative edge of a LL1,000 note up the side, all three embellishments suggesting circuits of information and physical movement.

Al-Murashah was the second Heartland intervention to take shape in Beirut. The first was called *Sarraf* (*Exchange*). Between August and November 2003, the group systematically stamped a series of words on Lebanese banknotes, photographed them, and then put them into circulation. The words were meant to evoke some aspect of Lebanese popular culture, from music and food to cars and cities where high numbers of Lebanese are living abroad. On LL20,000 notes, "Mercedes" and "Range Rover"; on LL10,000 notes, "Amr Diab" and "Wassouf"; on LL5,000 notes, "Paris", "Dubai" and "Montreal"; on LL1,000 notes, "Zaatar", "Foul" and "Rosto". In a brief description of the intervention, the members of Heartland state that the medium of money is "the simplest and most discreet way to pass on messages". Money, in effect, belongs to no one and moves indiscriminately among every one.

For a third outing in May 2005, during the show at the Laboratory entitled *Heartland Re-Prints*, billed as a collaborative project between Heartland and Espace SD, the group exhibited an archive of images from *Al-Murashah* and *Sarraf*. In addition, they sent off a package of papers in two sizes to the gallery, each stack labelled "7.5cm x 7.5cm of an intervention" and "21cm x 29.7cm of an intervention". The small papers — the size of street stickers, voting lists, or handwritten receipts from a

neighborhood shop — were left in a stack for viewers to take with them. The A4 papers were put up in various spots throughout the three-level gallery space.

The intervention was called *Propaganda*, and the point was to call attention to forms of communication and paths of information, opinion, and interpretation. "We do have the intention," note Heartland, "that people not only think about the notion of propaganda and its media but also intervene with the blank pages and at this point, the project does not just belong to us and starts to be a collective intervention, and anything can be expected."[1]

In each of these three projects, Heartland's approach is to take a chain of similar signifiers and basically insert a blank, one synaptic misfire that exposes the rest in their strangeness. To slip an image of a fictional candidate into a sea of actual campaign posters calls into question the entire election process in Lebanon, destabilising the relationship between a race of savage public postings on the one hand, and the political machinations happening at the same time behind closed doors on the other. Is Heartland's candidate any less recognisable than the others, any less real, less representative? What is the purpose of the visual spectacle accompanying all elections in Lebanon, whether municipal or parliamentary, if the results are known or at least presumed to be determined in advance in a process that has little to do with any public outpouring of support or rejection?

For the money project, Heartland's intervention mimics the banking practice of marking stacks of bills after taking final tallies. One can gauge how heavily a note has circulated by scanning its accretion of indecipherable ink marks. The intervention also begs the question, how out of place is the word *knefe* on a piece of paper, an abstraction representing currency value, that is already cluttered with such signs as the cedar tree, the Martyrs' Statue, and a slew of geometric graphics, all meant to symbolise a nation? *Sarraf* thus pinpoints a number of interesting links — money as a fetishised form of financial value and a reductive representation of national identity.

The propaganda project illustrates how easily information travels in urban environments. A pile of blank pages has the potential to become a public relations campaign for a DJ gig, promotional material for an advertising agenda, or the means by which political discontent may be publicly registered (as is the case with flyers frequently posted in Beirut objecting to UN Security Council resolutions or proposed changes in Lebanon's electoral laws that would tip the sectarian balance of power), or a propaganda campaign (as is the case when South Lebanon is periodically carpet-bombed with pamphlets warning that Hezbollah is "damaging" Lebanon). Such visual material appears always anonymously, mysterious traces surfacing without agency or an indication of authorship.

The members of Heartland describe their work as a missing piece and at the same time as an adhesion, an implication, and a challenge. Their projects create a tiny rupture on the surface of Beirut's visual culture. Similar to the work of graffiti artist Shepard Fairey — who describes street art as an exercise in phenomenology and who uses his worldwide "Obey Giant" sticker campaigns to question consumer culture, propaganda, and the ubiquity of advertising imagery in advanced capitalism — Heartland's interventions depend on their context for

1 Interview with Heartland via email, June 2005.

meaning, or rather, they interrupt their context to produce the potential for new meaning within it.

Because the image for *Al-Murashah* invariably ends up spliced among other material, Heartland's intervention exposes how heavily politicised and even militarised the visual material on the streets of Beirut remain. Why, fifteen years after the end of the civil war, for example, are fresh posters of long-dead or nearly dead adversaries from that conflict still populating the city's walls? Are pictures of religious leaders being posted out of respect or as a means of marking territory and barring entry to particular neighbourhoods? What are the psychological ramifications of living among a persistent accumulation of militia insignias? To what extent does all of this contribute to what sociologist Samir Khalaf describes as a renewed geography of fear in Lebanon?

Heartland implicates what already exists on the exterior of Beirut's urban fabric, but the collective also poses a challenge for residents and passers-by to recognise what is there and consider what could be. To throw an artistic intervention onto the city streets is as valid an effort at staking a claim for a youthful, edgy, cosmopolitanism as any gallery exhibition and arguably even more so.

What these and other recent interventions like Heartland's share is a desire to appropriate a part of the urban environment in Beirut that is distinct from the city's more obvious and monumental public spaces. Heartland's projects occupy the texture of everyday life. They make clear the extent to which urban experience exists primarily on street level, marked by a massive build-up of seemingly incidental visual material.

A glut of information takes up residence on the ground floor of densely packed, inner-city neighbourhoods, impressed on indeterminate or interstitial surfaces such as abandoned shops, temporary scaffolding, decayed buildings, and the walls blocking off vacant lots. This was always the point of graffiti, "thrust into the spaces of everyday life [and] in abandoned buildings and transit tunnels".[2] The impulse is to make one's mark and assert one's presence on surfaces that are largely ignored yet paradoxically highly visible. One notices a city's graffiti, its advertising, and its political propaganda only by way of persistence and accumulation.

At the same time, such material can be read as signs of life. A lived-in city appears like a palimpsest. The content reveals the character of a given neighbourhood, what goes on there, what people do, and what they care about; the thickness indicates the energy and vitality of it all; the turnover suggests internal tension and at the same time a level of tolerance for divergent expressions and constant activities.

Fifteen years into Beirut's post-war era, ten years into the city's contentious reconstruction project, and one year after the popular protests of 14 March, which reclaimed the public space of Martyrs' Square, Beirut's geographic and symbolic heart, these interventions by Heartland point to another, untapped layer of public space worth engaging which is simply the space of the city's streets. They also suggest that, in order to be effective, the appropriation and use of public space must be a repetitive practice.[3]

Urban interventions carry the potential to change, however slightly, the visual texture of the city. Heartland's projects in Beirut are ultimately additive in that they are not only disarming the remnants of the war but are also contributing new and more creative material to the city's surface as well. In this sense, they share kindred concerns with Anri Sala's

2 James and Karla Murray, *Broken Windows: Graffiti NYC*, Ginko Press, Corte Madera, 2002, p. 1.

3 Paul Connerton extends this argument to the formation of collective or social memory itself: "Images of the past and recollected knowledge of the past", he writes, "are conveyed and sustained by (more or less ritual) performances." Paul Connerton, *How Societies Remember*, Cambridge University Press, Cambridge, 1989, pp. 3–4.

Above: *Heartland, Sarraf (Exchange)*, 12 December 2003.
Stamps on original banknotes.
Opposite: *Heartland, Al Murashah (The Candidate)*, May 2004.
Silkscreen on A4 paper.

videos such as *Dammi I Colori* (*Give Me Colour*) (2003) and *Mixed Behaviour* (2003) — the first chronicling the controversial plan by Tirana's mayor, Edi Rama, to give colour to the city and its residents by painting the facades of housing projects in bright colours; the second a more pensive video of a DJ spinning records under a rain tarpaulin on a rooftop overlooking the city with New Year's fireworks exploding in the skies beyond. All these works suggest that aesthetic practices, impressed regularly on a city's surface, can, over time, reshape public experience.

By messing around with the traces of war inscribed on Beirut's exterior surface, artists such at Heartland are actively throwing those traces into question and attempting to diminish their power and persistence as symptoms of the post-war period.

What is perhaps most compelling about these urban interventions, in a local and international context alike, is their impulse towards collectivity and anonymity. To maintain complete anonymity is a way of circumventing censorship, the law, and meddlesome questions by the security services. But it is also a way to opt out of a dominant narrative that slots its subjects according to sect. To work in the guise of an anonymous collective frustrates the assumptions about group work in Beirut.

By refusing to disclose the authorship of its projects, using instead names and surnames that would be read as an assortment of known affiliations and allegiances, Heartland creates work in the public sphere that cannot, at first glance, be written off as the posturing of the roles assigned to, for example, a Maronite or a Sunni surname. The total shedding of identity allows these unknown artists to re-enter the city and create work related to the complicated experience of being, for example, male or female, rich or poor, gay or straight, religious or secular, educated or not, urban or not, professional or not, as individuals "inscribed in a multiplicity of social relations, the member of many communities, and participant in a plurality of collective forms of identification".[4] It allows them, in effect, to re-enter the city as far more complex citizens, with identities and subjectivities far more fragmented than those determined along sectarian lines alone. In this sense, Heartland's urban interventions carry the real potential not to solve Lebanon's identity crisis but to multiply and problematise it further and in more constructive ways.

BERNARD KHOURY ARCHITECTS
B018

B 018 is a music club, a place of nocturnal survival.

In the early months of 1998, B018 moved to The Quarantaine, a site that was better known for its macabre aura. The Quarantaine is located close to the port of Beirut. During the French protectorate, it was a place of quarantine for arriving crews. In the recent war it became the abode of Palestinian, Kurdish and South Lebanese refugees (20,000 in 1975). In January 1976, local militiamen launched a radical attack that completely wiped out the area. The slums were demolished along with the kilometre-long bordering wall that isolated the zone from the city. Over twenty years later, the scars of war are still perceptible through the disparity between the scarce urban fabric of the area and the densely populated neighbourhoods located across the highway that borders the zone.

The B 018 project is, first of all, a reaction to difficult and explosive conditions that are inherent in the history of its location and the contradictions that are implied by the implementation of an entertainment programme on such a site.

B018 refuses to participate to the naïve amnesia that governs the post-war reconstruction efforts.

The project is built below ground. Its façade is pressed into the ground to avoid the over-exposure of a mass that could act as a rhetorical monument. The building is embedded in a circular concrete disc slightly above tarmac level. At rest, it is almost invisible. It comes to life in the late hours of the night when its articulated roof structure constructed in heavy metal retracts hydraulically. The opening of the roof exposes the club to the world above and reveals the cityscape as an urban backdrop to the patrons below. Its closing signifies a voluntary disappearance, a gesture of recess. The building is encircled by concrete and tarmac rings. The automobiles' circular travel around the club and the concentric parking spots frame the building in a carousel formation. At night, the continuous motion of the visitors' cars animates the parking and becomes an integral element of the club's scenario. The entrance is located at the south end of the low-lying metal construction where a stair leads to two successive "airlock" spaces manned by scowling

bouncers. Strewn across the concrete pavement floor of the underground hall, the sofas with collapsible backs serve as elevated dancing surfaces that provide a stage for the performers.

Above and on following pages:
Bernard Khoury, *B018*, 1998.
Film stills.

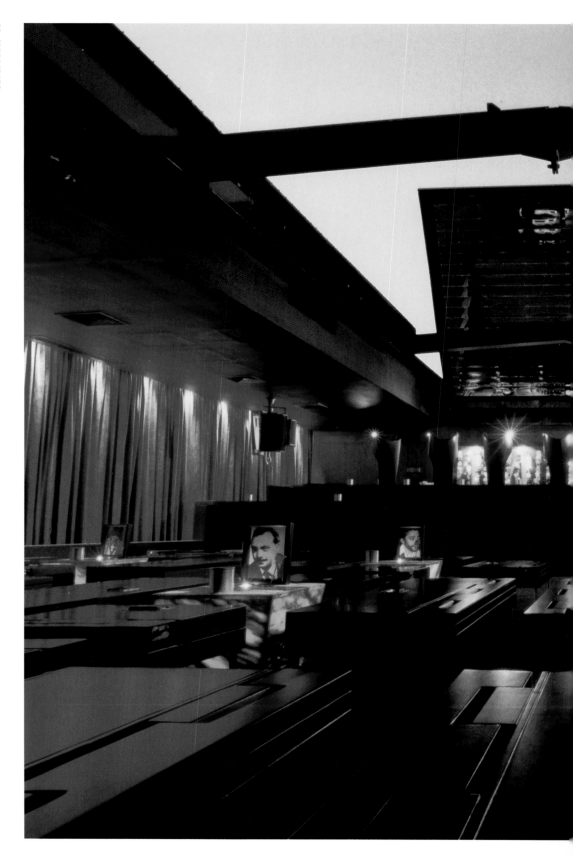

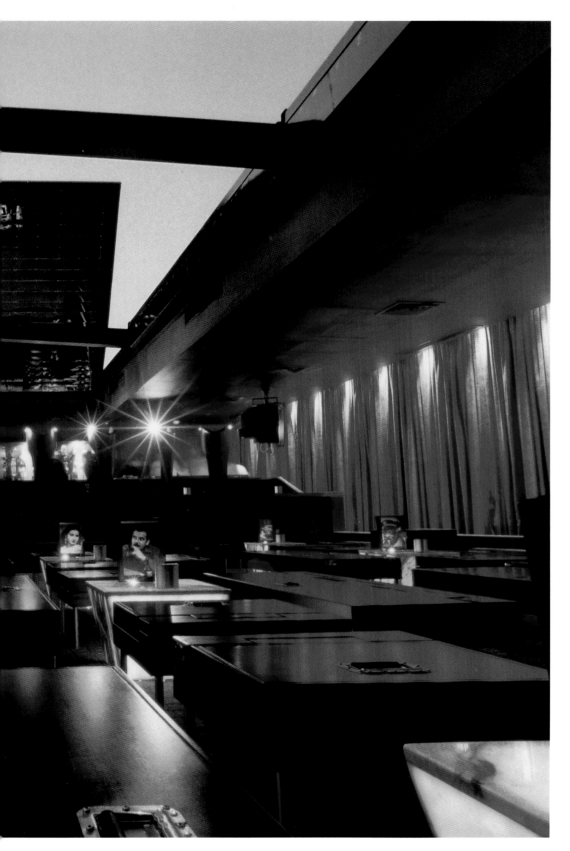

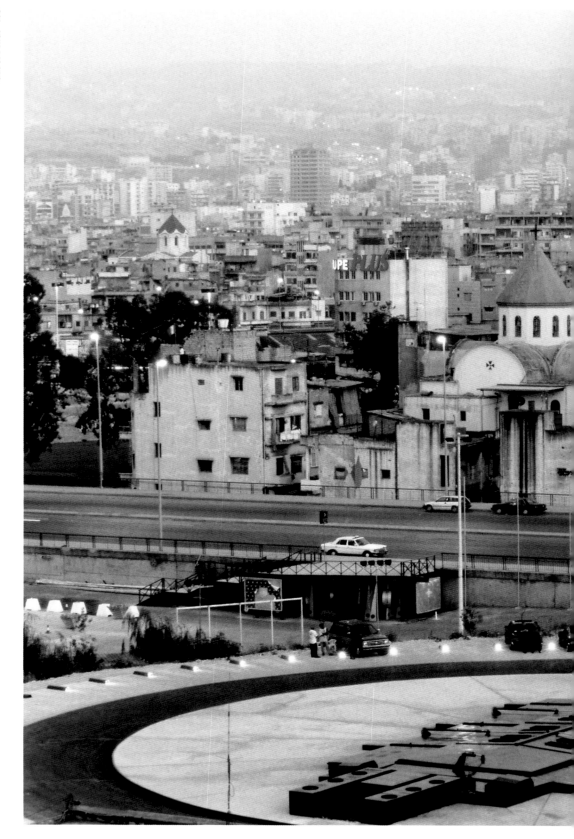

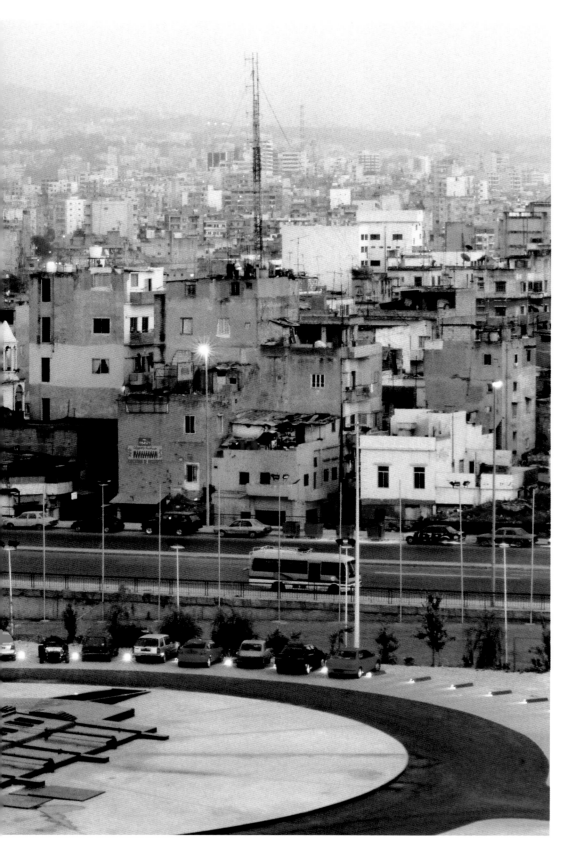

ALI CHERRI
UN CERCLE AUTOUR DU SOLEIL

Ali Cherri, *Un Cercle autour du Soleil*, 2005.
Film stills.

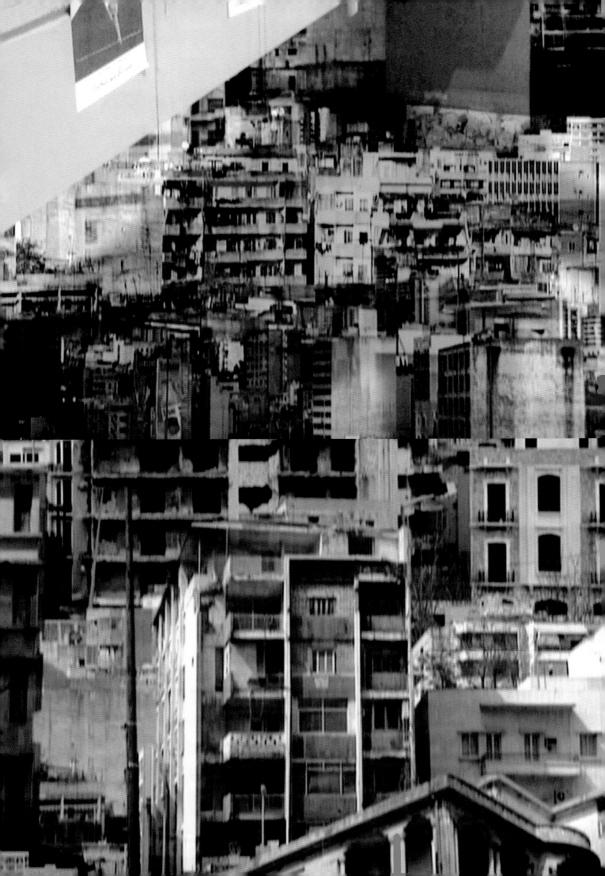

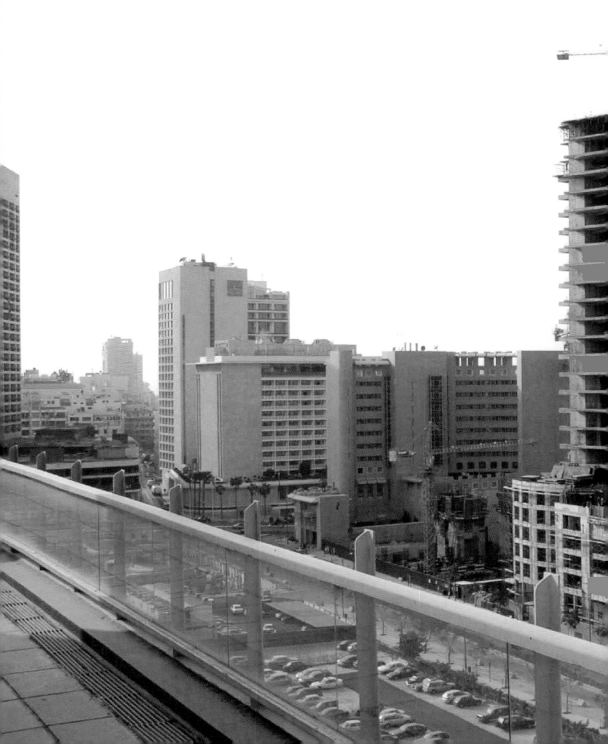

AKRAM ZAATARI
AFTER THE BLAST

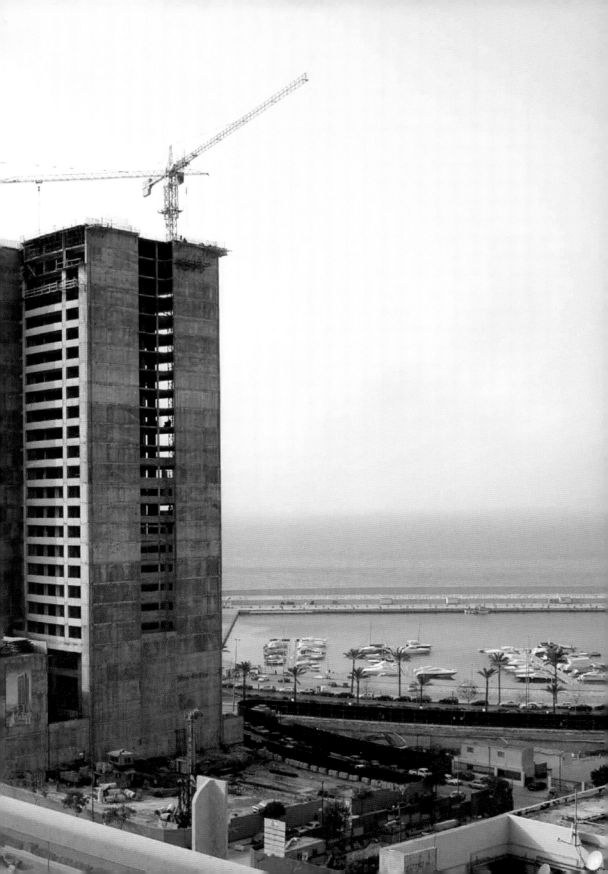

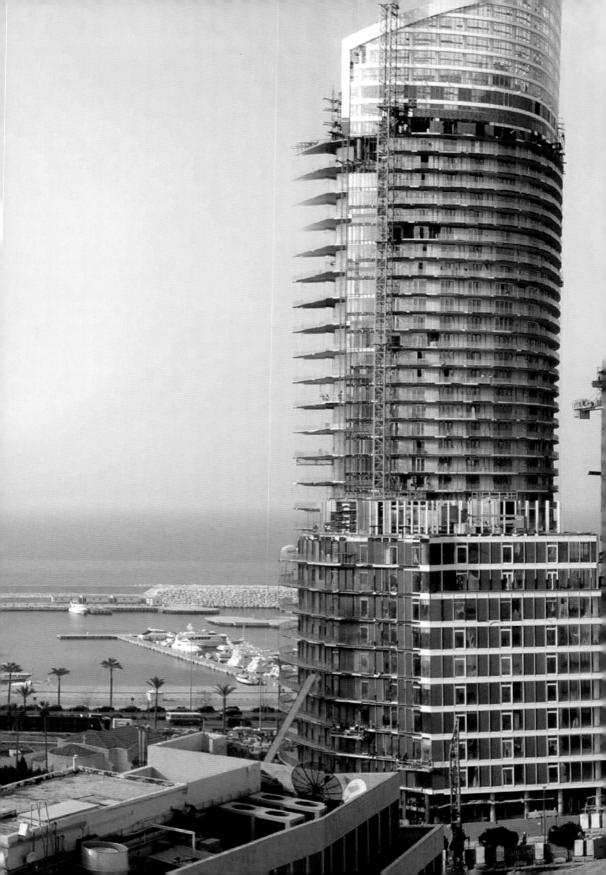

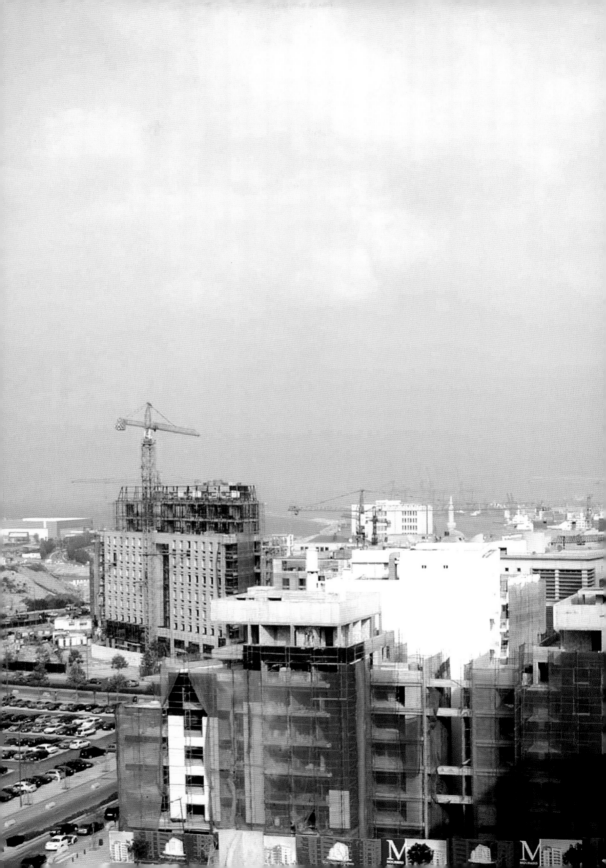

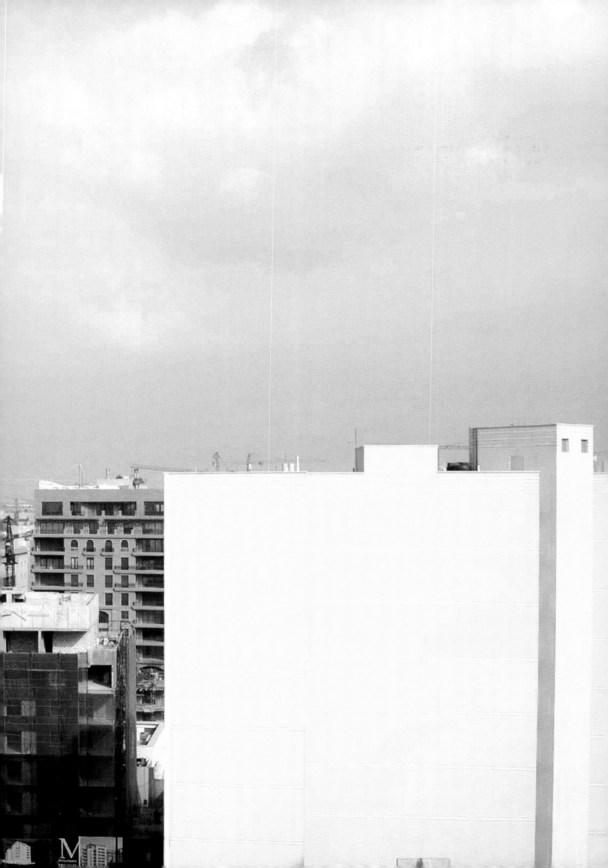

14 February 2005

14:49 The site of the blast as seen from AIF's office
in the Starco building.
14:49 Hundreds of people gathered at the site of the blast.
14:49 Broken windows from outside, in Starco building.
14:50 Broken windows from inside, in Starco building.
15:15 Staff members left the building as PM Hariri's death
was confirmed. I helped Zeina with her daughter Iris.
15:15 Starco building as seen from the street.

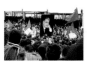

16 February 2005

12:36 Hariri's funeral in Martyrs' Square.
12:36 The Lebanese army surveying the site of Hariri's funeral.
15:02 Staff at Future Television station.

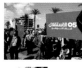

21 February 2005

1 Demonstrations started at the site of the blast before moving to
Martyrs' Square. People held slick slogans designed with the
slogan "Independence 05".
2 People gathered to sign a petition calling to stop violence.
3 People climbed public posts and signs.
4 People climbed public posts and signs.
5 There was heavy military presence, yet very peaceful.
6 "We miss you", a slogan that flew above Martyrs' Square.
7 People demonstrating for freedom of expression.
8 Media presence.
9 Giant Lebanese flag.
10 Monument to the Martyrs.

23 February 2005

1 Around the site of the blast most Hotels and office
buildings replaced broken windows with wood.
2 HSBC building, the closest to the blast.
3 The site of the blast, fenced.
4 HSBC building, the closest to the blast.
5 Phoenicia hotel, one of the most prestigious in the area.
6 Phoenicia hotel, one of the most prestigious in the area.
7 Palm Beach hotel, wrapped completely for restoration.
8 Hotel Vendome.
9 Hotel Vendome.

26 February 2005

1 Monument to the Martyrs wrapped in posters calling
for the truth in the relation to the killing of PM Hariri.
2 Slogans showing images of political and religious figures
killed in the past 30 years.
3 Slogans showing images of political and religious figures killed
in the past 30 years, and calling on Syria to withdraw its troops
out of Lebanon.
4 Memorial to PM Hariri.
5 Monument to the Martyrs wrapped in posters calling
for the truth in the relation to the killing of PM Hariri.
6 Signs alluding to Syria's responsibility in killing of Lebanese
political figures.
7 Each political party in the opposition was represented by a tent.

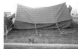
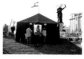
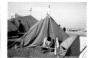

28 February 2005

1 Two weeks have passed after the assassination of PM Hariri. Early morning demonstration headed from Ashrafieh towards downtown Beirut.
2 On the edge of Martyrs' Square, people waited as The Lebanese army was besieging the square.
3 Around the square media were watching from building roofs.
4 The Lebanese Army was very peaceful, and was letting people into Martyrs' Square from time to time.
5 Many had already stayed over since the night before, in what was becoming a kind of camping site.
6 Around noon, hundreds of thousands were in Martyrs' Square.
7 Graffiti filled the portraits of Hariri.
8 Close-up of graffiti around Martyrs' Square where PM Hariri and former minister and MP Bassel Fleihan were buried.
9 A member of the Progressive Socialist Party climbed up one of the cranes present on site.

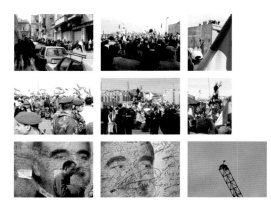

14 March 2005

1 People held anti-Syrian slogans and placards in Martyrs' Square.
2 Lebanese flags were everywhere.
3 For the first time people held up slogans making fun of Lebanese president Lahoud.
4 Young people painted their faces with the Lebanese flag.
5 Slogans made fun of President Lahoud speeches.
6 Slogans said "Liberty".
7 children held placards saying "the truth" and painted the Lebanese flag on their faces.
8 Thousands came to Martyrs' Square and on the bridges around it.
9 Tabaris crossroads, as people were leaving Martyrs' Square late in the afternoon

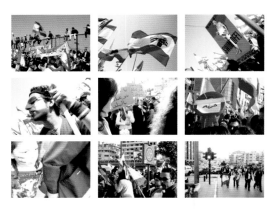

4th June 2005

Goodbye Samir Kasssir. Several thousands intellectuals pay tribute to writer and political activist Samir Kassir. His portrait was enlarged and displayed on the façade of *Al-Nahar* daily newspaper building on Martyrs' Square.

8 March 2005

1 Demonstration loyalty to Syria. People carried pro-Syrian posters and portraits, but often put them aside, or sat on them.
2 The demonstrations took place in Riad el Solh place, a few hundred metres from the Martyrs' Square site of anti-Syrian demonstrations.
3 People climbed public posts and signs.
4 In the demonstrations of opposition to Syria, people used only Lebanese flags as opposed to using flags of their political parties.

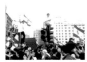

14th February 2006

1 Hariri's giant portraits were everywhere around Martyrs' Square
2 People brought their children along, not fearing threats of disorder.
3 People climbed over cranes with Lebanese flags.
4 Lebanese flags were dominant on the square .

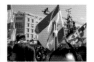

The exhibition

Ziad Abillama
Pourquoi n'Arrêtes-tu pas de Mourir? 2005.
Video transferred to DVD, 6.20 min. Courtesy of the Artist

Tony Chakar
A Window to the World 8, 2005.
8 digital prints, architects table and video projection on
7 min. loop. Courtesy of the Artist.

Ali Cherri
Un Cercle autour du Soleil, 2005.
Digital video, 15 min. Courtesy of the Artist.

Joana Hadjithomas & Khalil Joreige
Wonder Beirut: The Story of a Pyromaniac Photographer,
1998–2006.
18 postcards. Courtesy of the Artists.

Joana Hadjithomas & Khalil Joreige
Distracted Bullets. Symptomatic video Number1, 2005.
Video transferred to DVD, 15 min. 5,1 dolby surround.
Courtesy of the Artists and Ashkal Alwan.

Gilbert Hage
Tout un Chacun, 2005.
10 ultraChrome inkjet prints mounted on board.
50 x 50cm. Courtesy of the Artist.

Heartland
In Transit, 2006.
Floor graphics. Courtesy of the Artists.

Lamia Joreige
Here and Perhaps Elsewhere (Houna wa roubbama hounak),
2003. Video documentary. 54 min. Written, directed
and produced by Lamia Joreige. Co-produced by 03
productions. Editing: Michèle Tyan, Djinn house.
Sound: Rana Eid, Carole Issa. Courtesy of the Artist.

Bernard Khoury
B018, 1998.
Video transferred to DVD, 9.5 min. Courtesy of the Artist.

Rabih Mroué
Make Me Stop Smoking, 2006
Lecture/performance.

Walid Raad
*We Can Make Rain but No One Came to Ask: Plates 172,
237, 377, and 479*, 2007.
4 digital photographic prints, each 110 x 203cm, mounted
on aluminium. Courtesy of the Beirut Public Library, Maps
and Photographs Division.

Walid Sadek
Love is Blind, 2006.
10 text pieces on paper in Arabic and English, 10 vinyl
texts in Arabic and English. Perspex holders. 10 x 15cm.
Courtesy of the Artist.

Jalal Toufic
Mother and Son: A Tribute to Alexander Sokurov, 2006.
3 videos transferred to DVD, conceptual poster (*Mother and
Son*, 1982 version: 100 x 70cm), and photographic prints.
Courtesy of the Artist.

Paola Yacoub and Michel Lasserre
Summer 88, 2006.
12 photographic prints. 43.7 x 57cm.
Courtesy of the Artists.

Akram Zaatari
June 6, 1982, 2003–2006
Digital photograph. 254 x 127cm. Courtesy of the Artist
and Sfeir Semler Gallery.

Akram Zaatari
After the Blast,2006.
Digital photograph montage produced for the pages of *Out
of Beirut*. Courtesy of the Artist and Sfeir Semler Gallery.

Film programme, curated by Christine Tohme.
The *Lamentations* series: *The Ninth Night and Day*,
Jalal Toufic, 60 min., 2005.
Still Life, Haroun Farocki, 56 min., 1997.
From Beirut with Love, Wael Noureddine, Super-16,
30 min., 2005.
Jibraltar, Ghassan Halwani, animation, 15 min., 2005.
Kardesler, Deniz Buga, 7 min., 2003.
Nine Years Later, Dima El-Horr, 6 min., 2004.
Chic Point, Palestine, Sharif Waked, 7 min., 2003.

Contributors

Suzanne Cotter

Suzanne Cotter has been Modern Art Oxford Senior Curator since 2002. She has curated numerous exhibitions and has edited and written for their associated catalogues. Exhibitions for Modern Art Oxford include: *Angela Bulloch*, 2005; *Cecily Brown: Paintings* (cat.), 2005; *Fiona Tan: Countenance* (cat.), 2005; *Jannis Kounellis* (cat.), 2004; *Real World: The Dissolving Space of Experience* (cat.), 2004; *Mike Nelson: Triple Bluff Canyon* (cat.), 2004; *Candice Breitz: RE-ANIMATIONS* (cat.), 2003; *Monica Bonvicini: Anxiety Attack* (cat.) 2003. Recent writings include: "Each and Everyone", in *Fiona Tan: Vox Populi*, Bookworks, London, 2006 and "Cross Over", an essay on the work of Michael Clark, *Afterall*, issue 9, March, 2004, pp. 29–35. Suzanne Cotter is curator of *Out of Beirut*.

Simon Harvey

Born in England in 1963, Simon Harvey has worked in travel writing across Latin America. His PhD thesis was entitled *Smuggling in Theories and Practices of Contemporary Visual Culture* and he is currently a lecturer at the Art Academy, University of Trondheim (NTNU). While he occasionally writes for tourist-travel guidebooks, he is currently working on a project considering the performative potential of contraband in art and exhibition contexts.

Bilal Khbeiz

Born 1963 in Lebanon, Bilal Khbeiz is a writer, poet and installation artist. His work includes two poetry books, *A Memory of Air, Perhaps*, 1991, and *Of My Father's Illness* and *The Unbearable Heat*, 1997; a collection of essays, *That the body is Sin and Deliverance*, 1998; *Globalization and the Manufacture of Transient Events*, 2002; *The Enduring Image and the Vanishing World*, 2004; and a collection of postcards, *The Water is Cold in The Cafe*. He has worked since 1994 as an editorial secretary for the cultural supplement of the daily newspaper *Annahar*. He has participated in various exhibitions including The 6th Sharjah Biennale, United Arab Emirates, 2003 and *Dreams and Conflicts—The Dictatorship of the Viewer*, Venice Biennale, 2003.

Kaelen Wilson-Goldie

Kaelen Wilson-Goldie is a journalist based in Beirut and the arts and culture editor of *The Daily Star*, an English-language newspaper headquartered in Lebanon and distributed throughout the Middle East with the *International Herald Tribune*. She was born in Boston in 1975 and grew up in Massachusetts. In 1997, she earned a BA with high distinction in English literature and international relations from the University of Virginia. She earned an MS from the Columbia University Graduate School of Journalism in 1998, and an MA from the Center for Arab and Middle Eastern Studies at the American University of Beirut in 2006. She spent a number of years working as a writer and editor in New York before moving to Beirut in 2003. She has contributed to such publications as *The Village Voice*, *Flash Art*, *Art & Auction*, *Elle*, *Marie Claire*, *Photo District News*, *Variety*, *Bidoun*, *Dutch*, and more. She was the senior editor of the magazine *Black Book* from 2000 to 2003. She has written several essays for exhibition catalogues and books, most recently a piece on the sexual dimension of the Middle Eastern textiles trade for *The Secret Life of Syrian Lingerie: Intimacy and Design*, Scalo and the Prince Claus Fund, 2006, edited by Malu Halasa. Her work here is adapted from her master's thesis, entitled 'Digging for Fire: Contemporary Art Practices in Postwar Lebanon', a project on which she is currently working to expand and refine.

Stephen Wright

Born in 1963 in Vancouver, Canada, Stephen Wright is an art critic and programme director at the Collège International de Philosophie, Paris. In 2004, he curated *The Future of the Reciprocal Readymade*, Apexart, New York, in 2005 *In Absentia*, Passerelle, Brest. He is currently working on *Rumour as Media*, Aksanat, Istanbul, as part of a series of exhibitions examining art practices with low coefficients of artistic visibility, which raise the prospect of art without artworks, authorship or spectatorship. Stephen Wright lives in Paris.

Artists' Biographies

Ziad Abillama

Ziad Abillama studied at Amherst College, Massachusetts, and the Rhode Island School of Design. In 1992 he produced the influential piece *Untitled*; in which he cleared a public beach north of Beirut of piles of rubbish, enclosed the area with barbed wire and steel posts, and placed inside it discarded weapons, scrap metal and other remnants of military equipment from the civil war. From 1991 to 1998, Abillama primarily made sculptures, and for many years refused to show outside Lebanon. In the early 1990s he collaborated with the architect Bernard Khoury on *Counter Proposal*, a proposal for the redevelopment of Martyrs' Square, Beirut. He returned to film school in Beirut in 2003.

Tony Chakar

Tony Chakar is an architect, born in Beirut in 1968. His works include: *A Retroactive Monument for a Chimerical City*: Ashkal Alwan, Beirut,1999; *All That is Solid Melts into Air*, Ashkal Alwan, Beirut, 2000; *4 Cotton Underwear for Tony*, Ashkal Alwan, TownHouse Gallery, Cairo, also shown in Barcelona, Tàpies Foundation and Rotterdam Witte de With as part of *Contemporary Arab Representations*, a project curated by Catherine David in 2002; *Rouwaysset: A Modern Vernacular* (With Naji Assi), *Contemporary Arab Representations*, the Sharjah Biennial and São Paolo, 2001– 3; *Beirut: The Impossible Portrait*, in *Dreams and Conflicts — The Dictatorship of the Viewer*, Venice Biennale, 2003; *The Eyeless Map*, Ashkal Alwan, Beirut, 2003; *My Neck is Thinner than a Hair*, a lecture/performance with Walid Raad and Bilal Khbeiz, shown in Beirut, Brussels, Paris, Berlin, London, Basel and Singapore, 2004; *A Window to the World*, Ashkal Alwan, Beirut, 2005. He also contributes to *Al Mulhaq*, the cultural supplement of *Annahar*, *Untitled*, *Freize* and *Bidoun* magazines. Chakar teaches History of Art and History of Architecture at the Académie Libanaise des Beaux Arts (ALBA), Beirut.

Ali Cherri

Born in Beirut in 1976, Ali Cherri studied Graphic Design at the American University of Beirut and Performing arts at DasArts, Amsterdam. His performances and installations include *As Dead as Ever*, 2002, and *RedRum* with Guy Amitai in 2003, both at DasArts, Amsterdam. In 2002, Cherri collaborated with Rabih Mroué and Lina Saneh on *Biokraphia*, a performance presented in venues across Europe including the Cartier Foundation, Paris and HAU 1,

Berlin in 2004. In 2005, he presented his first performance of *Give Me a Body Then* in Amsterdam, Giessen and at *the Home Works III: A Forum for Cultural Practices*, Beirut, 2005. His video *Un Cercle autour du Soleil* received the FAAP digital arts award at the 15th VideoBrazil, Sao Paolo (2005).

Joana Hadjithomas and Khalil Joreige

Joana Hadjithomas and Khalil Joreige were born in Beirut in 1969. Hadjithomas teaches Scriptwriting, and Joreige teaches Aesthetics and Philosophy of the Image, at the Institute for Scenic & Audiovisual Studies (IESAV), University of St Joseph's in Beirut. Their first feature film, a French-Canadian and Lebanese co-production, *Al Bayt el Zahr (Around the Pink House)*, 1999, was followed by *Khiam*, 2000, and *Ramad (Ashes)*, 2003, with Rabih Mroué. *The Lost Film*, 2003, a reflection on the place of the image in Arab culture, was screened at the ICA, London as part of the LIFT festival in 2004. Their latest feature film *A Perfect Day*, a French and European co-production, was shown as part of the London Film Festival, 2005, and won the International Critics' Prize at the Locarno Film Festival. Recent video and photography exhibitions include *Beirut: Urban Fictions, The Circle of Confusion, Don't Walk, Lasting Images* and *Wonder Beirut: The Story of a Pyromaniac Photographer, Postcards of War* and *Latent Images* (1998– 2006). *Distracted Bullets* is the first in their "symptomatic video" series. The artists have produced various articles and publications including; *Beirut: Urban Fictions,* 1997, and *Ok I'm Going to Show You My Work*, 2002.

Gilbert Hage

Born in 1966 in Beirut, Gilbert Hage teaches Photography at Kaslik University, Lebanon, from where he graduated and at the Académie Libanaise des Beaux-Arts, Université de Balamand. His project *Ici et Maintenant* presents portraits of the contemporary generation of young people in post-war Lebanon. *Ici et Maintenant* has been shown at Espace SD, Beirut,2004, and Haus der Kulturen der Welt, Berlin, 2005.

Heartland

Began working in Lebanon as an anonymous artistic collective in 2003. The collective works anonymously in order to ensure an absence of systematic references to names, physical descriptions or communities in a

country where every name, act or action seems to directly refer to an organisation, whether it is social, political, religious or artistic. Heartland focus on artistic interventions in public and individual places, finding interest in working in different contexts. Their objective is a neutral implication in daily life in Beirut. Their brief interventional history includes *Sarraf*, 2003, *Al Murashah*, May 2004, and *Propaganda*, Espace SD, 2005.

Lamia Joreige

Born in Beirut in 1972, Lamia Joreige emigrated to France in 1983. In 1992, she went to the USA and studied Cinema and Painting at the Rhode Island School of Design. She lives in Beirut. Her work has been featured in exhibitions including *Missing Links*, Townhouse Gallery, Cairo, 2001; *Possible narratives*, VideoBrazil, São Paolo; *Present Absence*, Tanit gallery, Munich; *DisORIENTations*, House of World Cultures, Berlin, 2003; *Laughter*, LIFT, Bargehouse, London, 2004. She has had solo exhibitions at Nikki Marquardt Gallery, Paris, 2000; *Ici et peut-etre ailleurs*, at Nicéphore Niépce Museum, France, 2003 and at Janine Rubeiz Gallery, Beirut, from 1999 to 2004. Among her works: *Objects of war*, ongoing since 1999; *Time and the Other*, exhibition and book published by Alarm Editions, Beirut, 2004; *Untitled 1997–2003*; *Replay* (bis), 2002; *Replay*, 2000; *Here and Perhaps Elsewhere*, 2003; *Ici et peut-être ailleurs*, fiction published by H.K.W., Berlin, 2003, and *The Displacement*, 1998–2000.

Bernard Khoury

Born in Beirut in 1968, Bernard Khoury studied Architecture at the Rhode Island School of Design from 1990 to 1991. He received a Master's Degree in Architectural Studies from Harvard University in 1993. In 2001, he was awarded, by the municipality of Rome, the honourable mention of the Borromini Prize given to architects under 40 years of age. He is the author of several experimental projects including *Evolving Scars*, produced in 1993 in the form of a proposal for the restoration and progressive transmutation of war-damaged buildings in Beirut. His best-known public commissions in Beirut include the nightclub *BO18*, 1998, built on the site of the former quarantine area of the port, and the restaurant *La Centrale*, 2001. His work has been extensively published in numerous specialised magazines worldwide. He has had a solo exhibition: *Plan B, Bernard Khoury*, AEDES Gallery,

Berlin, 2003, and has held several seminars: Harvard University Graduate School of Design, 2003; the Triennale de Milano, 2000–4; The Royal Academy of Arts, London, 2005; The Massachusetts Institute of Technology (MIT), 2006; and several others. He is currently working on larger-scale building commissions in Beirut, Kuwait, Oman and Riyadh.

Rabih Mroué

Born 1967 in Beirut, Rabih Mroué is an actor, director, and playwright. In 1990 he began putting on his own plays, performances, and videos. Mroué's practice questions the definitions of theatre and the relationship between space and the form of the performance. His semi-documentary theatre uses documents, photos and found objects, to draw attention to the broader political and economic contexts in contemporary Beirut. His 2002 collaboration with Lina Saneh, *Biokhraphia* provided a space to consider the invention of biography, with all its dreams, failings, and idiosyncrasies, within the frame of the beginning of a history. In the performance *Looking for a Missing Employee*, 2003, Mroué become a "detective" interested in using actual documents to understand how rumours, public accusations, national political conflicts, and scandals act on the public sphere as shaped by the print media. *Who's Afraid of Representation?*, 2004, merged parallel histories of Western performance art and contemporary socio-political events in Beirut. Other projects include, *L'Abat-Jour*, 1990; *Three Posters*, with Elias Khoury, 2000; *Face A / Face B*, short film, cine poème, 2001; *Limp Bodies*, 2003 and *Look at the Light Moving between the Buildings*, 2006. Since 1995 he has worked for the television company Future TV where he makes animated films and documentaries.

Walid Raad

Walid Raad is an artist and an Associate Professor of Art at Cooper Union, New York. Raad's works to date include mixed-media installations, video and photography as well as literary essays. Raad's video works include *I Only Wish That I Could Weep*, 6 min., Raad, 2003; *Hostage: The Bachar Tapes*, 18 min., Raad/Bachar, 2000; and *We Can Make Rain but No One Came to Ask*, 18 min., Raad, 2006. Mixed-media installations and lectures include *The Truth Will be Known When the Last Witness is Dead: Documents from Fakhouri File in The Atlas Group Archive*, installation,

2003–; *The Loudest Muttering is Over: Documents from The Atlas Group Archive*, 60 min., lecture, 2001–, and *My Neck is Thinner Than a Hair*, 75 min., lecture, 2005. His works have been shown at *Documenta XI*, Kassel, 2002, the Whitney Biennial, New York, 2002, *Dreams and Conflicts— The Dictatorship of the Viewer*, Venice Biennale, 2003; *Home Works III: A Forum for Cultural Practices*, Beirut, 2006; and numerous other museums and venues in Europe, the Middle East and North America. Walid Raad is also a member of the *Arab Image Foundation* (Beirut/New York— www.fai.org.lb) and a founding member of *The Atlas Group* (Beirut/New York—www.theatlasgroup.org).

Walid Sadek

Born in 1966, Walid Sadek is an artist and writer living in Beirut. As an artist he has exhibited *Les Autres*, 2001, *Al Kassal (Indolence)*, 1999, with writer Bilal Khbeiz, *Bigger Than Picasso*,1999, and *Karaoke*,1998. He has essays published in magazines such as *Parachute*, *Zehar*, *Al Adab* as well as in the volumes *Tamáss*, 2001, *Territoire Mediterranee*, 2005, and *Notes for an Art School*, *Documenta 6*, Nicosia, 2006. He has also published a collection of essays entitled *Jane-Loyse Tissier*, 2003. Sadek is currently Assistant Professor at the Department of Architecture and Design at the American University of Beirut.

Jalal Toufic

Born in Lebanon in 1962. Jalal Toufic is a writer, film theorist and visual artist. He is the author of *Distracted*, 1991, 2nd edn., 2003; *(Vampires): An Uneasy Essay on the Undead in Film*, 1993, 2nd edn., 2003; *Over-Sensitivity*, 1996; *Forthcoming*, 2000, *Undying Love, or Love Dies*, 2002; *Two or Three Things I'm Dying to Tell You*, 2005; and *Âshûrâ: This Blood Spilled in My Veins*, 2005. His videos and mixed-media works, which include *Credits Included: A Video in Red and Green*, 1995; *The Sleep of Reason: This Blood Spilled in My Veins*, 2002; *Âshûrâ: This Blood Spilled in My Veins*, 2002; *Saving Face*, 2003; *A Special Effect Termed "Time"*, or, *Filming Death at Work*, 2005; and *The Lamentations Series: The Ninth Night and Day*, 2005, have been presented internationally, at such venues as Artists Space, New York; Witte de With, Rotterdam; Fundació Antoni Tàpies, Barcelona; and the 16th International Documentary Filmfestival Amsterdam (IDFA) in a "Focus Jalal Toufic" programme. Toufic has taught at the University of California at Berkeley, California Institute of the Arts,

USC, and, in Amsterdam, DasArts and the Rijksakademie. He started and is the Head of the MA programme in Film/ Video Studies at Holy Spirit University, Lebanon. He will be a teacher and adviser at Manifesta 6, Nicosia, Cyprus, autumn 2006. www.jalaltoufic.com

Paola Yacoub and Michel Lasserre

Paola Yacoub and Michel Lasserre were born, respectively, in Beirut in 1966 and France in 1947. They have been collaborating as artists since 2000. Paola Yacoub studied Architecture at the Architecture Association and Fine Arts at St. Martin's School of Art in London. She also studied Archeology at the Institut Français d'Archéologie du Proche-Orient and worked as part of an archaeological team on sites in Beirut after the civil war. Michel Lasserre studied architecture at UP7 and Philosophy at Université de Vincennes, both in Paris. In 2004, the artists moved from Paris to Berlin to take up a fellowship with the DAAD Artist's Programme. Their work has been the subject of solo exhibitions at Kunst-Werke, Berlin, 2001; Le Plateau, Paris, 2002; Malmo Kontsthall, Sweden, 2003–4, Museu d'Art Contemporani de Barcelona, 2004 and at DAAD Galerie, Berlin, 2005. Group exhibitions include *Supplements* at *Lucky Seoul*, The Japan Foundation Japan Cultural Center and Insa Art Space, Seoul; *Dreams and Conflicts — The Dictatorship of the Viewer*, Venice Biennale, 2003; *Haus Lewin* at *After the Fact*, 1st Berlin Photography Festival, 2005. Their photo-essays were anthologised recently in the publication *Beirut is a Magnificent City: Synoptic Tables*, published by the Fundacio Antoni Tàpies in 2003 as part of the series of exhibitions, discussions and presentational platforms, *Contemporary Arab Representations*, curated by Catherine David in 2002 at Witte de With, Rotterdam and Fundació Antoni Tàpies, Barcelona.

Akram Zaatari

Born in Saida, Lebanon in 1966, Akram Zaatari is a video artist and curator who lives and works in Beirut. Author of more than 30 videos, and video installations, Zaatari has been exploring issues pertinent to Lebanese post-war condition, particularly the mediation of territorial conflicts and wars through television, the logic of religious and national resistance, and the production and circulation of images in the context of a geographically divided Middle East, particularly in *This Day*, 2003; *In This House*, 2005 and *All is Well on the Border*, 1997. Zaatari's concern with

subversive social issues led him to explore representations of male sexuality particularly in *Crazy of You*, 1997, and later in *How I Love You*, 2001. Co-founder of the Arab Image Foundation, Beirut, Zaatari has based his work on collecting, studying, and archiving the photographic history of the Middle East, notably the study of the work of Lebanese photographer Hashem el Madani (1928–), as a register of social relationships and of photographic practices. His ongoing research has formed the basis of a series of exhibitions and publications such as *Hashem El Madani: Studio Practices* (with Lisa Le Feuvre), and *Mapping Sitting*, in collaboration with Walid Raad. He has contributed to numerous critical journals including, *Third Text*, *Bomb*, *Framework*, *Transition* and *Parachute*. He regularly writes on video for the cultural magazine *Zawaya*. He has exhibited in Portikus, Frankfurt, Centre Pour l'Image Contemporaine, Geneva, Musée Nicéphore Nièpce, Chalon-sur-Saône, Photographers' Gallery, London, and VideoBrazil, São Paolo. In 2006 Zaatari's work will be presented at the Sydney, Gwanju and São Paolo biennales.

With additional thanks to:

Nidal Abu Mrad, Pierre Abi-Saab, Negar Azimi, Kathy Battista, Shumon Basar, Iwona Blazwick, Lionel Bovier, Deniz Buga, Dr. Michael Burdon, Lucy Byatt, Antonia Carver, Paul Daniels, Catherine David, Maggie Davies, Bernard Dod, Dima El-Horr, Fouad ElKhoury, Kodwo Eshun, Harun Farocki, Lisa Le Feuvre, Stephen Foster, Joan Fraser, Emma Gernez, Luckas Haller, Malu Halasa, Ghassan Halwani, Sune Haugbolle, Alan Haydon, Ian Hutchinson, Thomas Karshan, Alexis Kirschbaum, Jo Lanyon, Catherine Luck-Taylor, Laetitia Manach, Penelope Marcus, Samar Martha, His Excellency Jihad Mortada, Francesco Manacorda, Costanza Mazzonis di Pralafera, Lena Merhej, Wael Noureddine Marwan Rechmaoui, Masha Refka, Anthony Reynolds, Irit Rogoff, Anjalika Sagar, Salome Schnetz, Andrée Sfeir-Semier, Karl Sharro, Nadim Shehadi, James Speake, Rochelle Steiner, Nadine Touma, Tom Trevor, Sharif Waked, Richard Wentworth, Liz Whitehead.

Published on the occasion of OUT OF BEIRUT
Modern Art Oxford ██ Pembroke Street, Oxford OX1 1BP, England

Organised by Modern Art ██
Curated by Suzanne Co██ ██k
Assistant Curator: Joha██
Programme Administra██
Gallery Manager: Tom L██
Curatorial Intern: Cathe██
Curatorial Consultant a██
film programme: Christ██

Edited by Suzanne Cott██
Editorial Co-ordination██
Copy Editor: Bernard D██
French/English translati██
Suzanne Cotter

Design by SMITH
Victoria Forrest

Printed by Dexter Grap██

All images courtesy of ██
Sfeir Semler Gallery; pp██

Modern Art Oxford, th██
All rights reserved. No ██
reproduced, stored in a██
in any form or by any ██
photocopying or other██
artists, authors and M██
texts are copyrighted by the artists and authors.

Distributed in the UK by Cornerhouse Publications
70 Oxford Street, Manchester M1 5NH
Tel: +44 (0)161 200 1503
Fax: +44 (0)161 200 1504
publications@cornerhouse.org
www.cornerhouse.org/books

Distributed outside the UK by JRP | Ringier
Letzigraben 134, CH-8047 Zurich
Tel: +41 (0) 43 311 27 50
Fax: +41 (0) 43 311 27 51
info@jrp-ringier.com
www.jrp-ringier.com

Distributed in the USA by D.A.P./Distributed Art Publishers
155 Sixth Avenue, 2nd Floor, USA-New York, NY 10013
dap@dapinc.com
www.artbook.com

ISBN 10: 3-905701-90-1
ISBN 13: 978-3-905701-90-6
ISBN 10: 1-901352-28-5 (UK only)
ISBN 13: 978-1-901352-28-3 (UK only)

Modern Art Oxford is supported by Oxford City Council,
Arts Council England, South East, and the Horace W.
Goldsmith Foundation.

Museum of Modern Art. Registered charity no. 313035

MODERN ART OXFORD

OFFICIAL AIRLINE

Supported by
The National Lottery®
through Arts Council England

supported by
Visiting Arts

●● **BRITISH COUNCIL**
Lebanon
